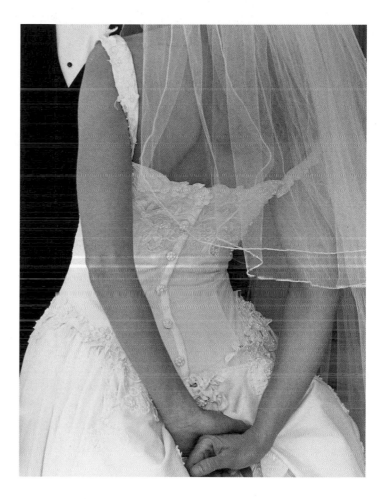

THE ART OF

WEDDING

PHOTOGRAPHY

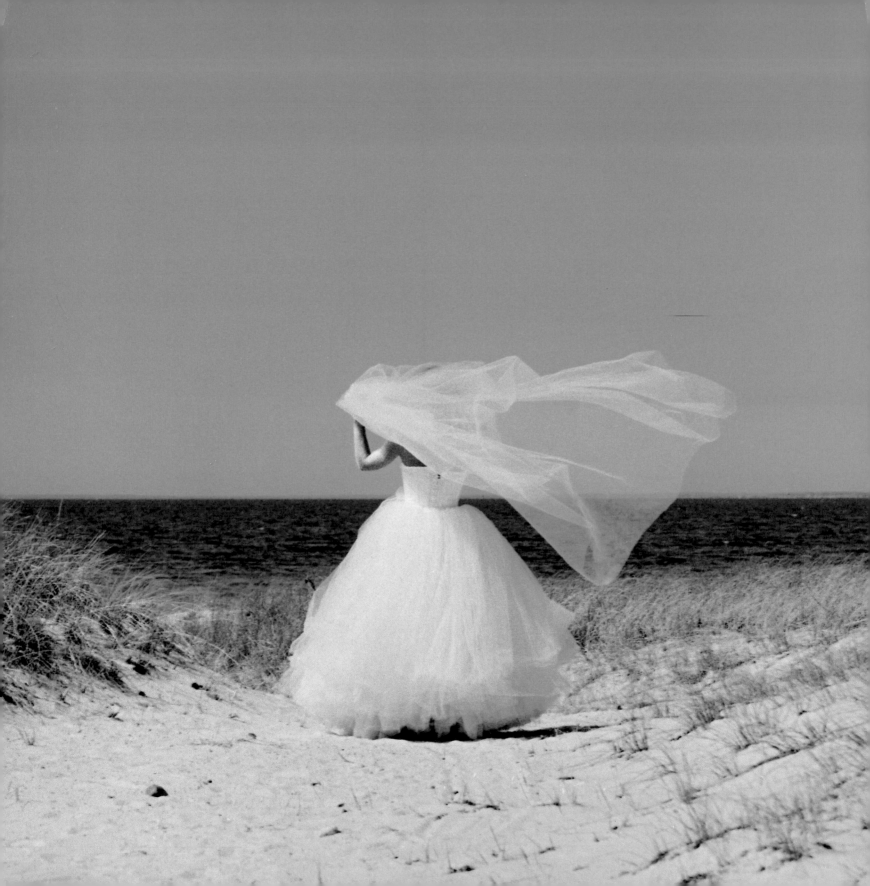

THE ART OF

WEDDING

PHOTOGRAPHY

Professional Techniques with Style

BAMBI CANTRELL

TEXT BY SKIP COHEN

AMPHOTO BOOKS

an imprint of Watson-Guptill Publications

To MARILYN CANTRELL,
for her persistent belief that nothing is impossible,
AND TO DON BLAIR,
who never stops teaching, learning, and inspiring.

All photographs by Bambi Cantrell except on page 6 (by Denis Reggie) and the author photo on the back flap (by Tony Corbell).

All images taken with only available light unless otherwise specified.

Credits:
Page 66: San Francisco Ritz-Carlton Hotel
Page 101: Garden Court, Sheraton Palace Hotel, San Francisco
Page 102: Floral arrangements by Laura Little, Floramor Studio, San Francisco; Connie Olson Kearns, Bridal Network Wedding Coordinator

Senior Editor: Victoria Craven
Editor: Julie Mazur
Designer: Areta Buk
Production Manager: Ellen Greene
Text set in 11-pt. Adobe Garamond

First published in 2000 by
Watson-Guptill Publications,
a division of VNU Business Media, Inc.,
770 Broadway, New York, NY 10003
www.watsonguptill.com

Library of Congress Cataloging-in-Publication Data
Cantrell, Bambi.
 The art of wedding photography : professional techniques with style / by
 Bambi Cantrell and Skip Cohen.
 p. cm.
 Includes index.
 ISBN 0-8174-3325-2
 1. Wedding photography. 2. Photography—Business methods. I. Cohen, Skip. II. Title.

 TR819.C36 2000
 778.9'93925—dc21

 00-034844

Printed in Italy

First printing, 2000

5 6 7 8 9 / 08 07 06 05 04

CONTENTS

FOREWORD

by Denis Reggie

For better or worse, wedding photographers seem to operate with two divergent mandates and definitions of art and correctness. The mission of the "traditional" wedding photographer is to arrange and create photographic opportunities; for the "wedding photojournalist," it is to sense and find, to document, existing moments. Two perspectives, two missions, two minds: the one proactive, the other reactive.

The so-called traditional approach was born from the ranks of portrait photographers in the 1970s and is exemplified by images of subjects who are at least aware of, if not participating in, the process. The classic portrait of a bride gazing at her bouquet while the groom peers at her from a distance is the hallmark of the genre, but the traditional mindset and priorities are evident even in action scenes, like those of the first dance or the cutting of the wedding cake, in which a couple is prompted for eye contact with the lens. Such portraitists are intent on having faces directed toward the camera, and are in essence photographing the participants rather than the event itself.

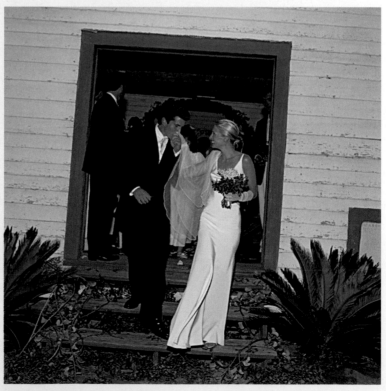

To be sure, when done well, the traditional approach is still popular with many clients. In fact, as of this writing, the overwhelming majority of photographers still adopt the traditional approach—whether they'll freely admit to it or not. But a growing segment of the market is demanding images of reality without intrusion, and the race is on to satisfy such clients.

"Wedding photojournalism" was defined in the 1980s (though not in the mainstream until the mid-1990s) to respond to an increasing demand for genuine, nonposed coverage: moments captured, the telling of the actual story rather than a series of arranged concoctions. Wedding photojournalists are reporters, followers who quietly observe and quickly document without manipulating the scene or subject. Their belief: To be art, there must be authenticity. Technical innovations in cameras, lenses, and faster films have allowed their pursuit to flourish, just as the unwieldy equipment, heavy-duty lighting, and slower films of days past must have encouraged the birth of traditional, portrait-like photography, with its lack of spontaneity.

One example of wedding photojournalism is my 1996 photograph of Carolyn Bessette and John Kennedy, Jr. exiting their secret Cumberland Island ceremony (shown opposite). Under camouflage of darkness and to the bride's blissful surprise, John reached for her hand and kissed it firmly. Both were glowing and neither were cognizant of my presence: The scene is precisely as it was without manipulation. The image was published and broadcast worldwide based on the couple's direction to release only one image to the media. I chose that particular photograph because I felt it would communicate the heartfelt romance and magical ambience of that evening. After appearing on the covers of more than 1,100 newspapers and magazines, it was featured among the "photographs of the year" by *Time, People,* and *Life* magazines.

The current onslaught of wedding photojournalism is surely due in great part to a consumer trend toward naturalness. Reality with all its flaws is winning out over perfection created artificially. There is still a demand for posed portraits, but often less than ten percent of the total album will contain images of subjects who are actively aware of the camera. Today, couples simply want to enjoy their wedding and the celebration of family without hours spent posing—hours that interrupt the day's natural flow. They want an album that's a statement about themselves and not a testament to the photographer's imposed will. As ever, demand shapes supply, and it is the photographers sensitive to such wants who shall find success.

PREFACE

Nontraditional techniques will allow you to take dramatic portraits anywhere, even against an everyday, nondescript wall. Bambi took this portrait of the bride in a public restroom!

HASSELBLAD 503CW, 30MM CF FISHEYE LENS, f4.0 AT 1/4, KODAK CN

In March 1998, at the WPPI (Wedding and Portrait Photographers International) convention in Las Vegas, more than six hundred people came to hear a relatively new speaker named Bambi Cantrell discuss the latest trends in wedding photography. The response from the crowd was overwhelming. In fact, the question and answer session at the end of the program lasted almost as long as the program itself. The crowd simply wouldn't let Bambi leave! Since then, this same scenario has played out over and over again—every time Bambi presents her thoughts on wedding photography. And after every program there's a feeding frenzy for more information.

What makes Bambi's message so powerful is her love for the craft and the time she puts into managing and marketing her business. She reads virtually every magazine her clients are likely to read—not just the bridal books, but also magazines such as *Vogue, Vanity Fair,* and *Cosmopolitan.* She spends at least half of her free time trying to understand the purchasing trends of her clients. As a result, Bambi never misses. She's never caught "up against the wall" without being able to meet the mindset of the bride and groom. No matter where a wedding takes place, Bambi manages to create an album of contemporary images that go far beyond her clients' expectations.

At virtually every one of Bambi's seminars, someone asks, "Isn't there a book on this stuff?" Having worked with Bambi for many years through Hasselblad USA, one of her corporate sponsors, I decided it was time to put her thoughts on paper. Over a year's time we explored the different factors that go into creating exciting images and a terrific wedding album, and that help build a photographer's reputation for quality. This book is the result. Our hope is that it will help wedding photographers elevate their craft beyond the simple technique of taking pictures, to the creation of dramatic images that speak directly to their clients. And as for brides and grooms, we hope to help them understand the importance of a wedding album that will last for generations to come.

The Art of Wedding Photography is based on Bambi's unique approach to photography. She has earned the respect of the entire photographic industry and, more importantly, has become a friend to so many of us. If nothing else, she's taught us that if we're caught "up against the wall" it will only be because that was the best place to get the shot!

Skip Cohen

ACKNOWLEDGMENTS

No project of this magnitude could ever be done by just two people. We never would have gotten this book off the ground without the support of our families. While some professions allow you the luxury of removing yourself from the environment and forgetting about the "job" when you go home at night, photography is a nonstop occupation. You never stop thinking about creating images. You look at a scene and wish you had a camera. You see a couple walking down the street, hand in hand, and wonder if you're good enough to capture the emotion between them on film. So, to Steve and Cameron, Debbie, Jaime, Adam, and Lisa, thank you for your never-ending support. We couldn't have done it without you!

A special thanks goes to Denis Reggie, not just for contributing the foreword, but for his continuous inspiration to wedding photographers all over the world. His concepts, philosophy, and professional skill have helped elevate our craft and the business of wedding photography. He's changed the way we tell every story of each new family's beginning.

Many of the book's early design concepts were the product of Johnathan Kaufman, an incredibly talented young designer. His patience throughout the first six months helped us turn our ideas into reality.

The photographic industry is loaded with wonderful people, but an isolated few seem to have unlimited talent and enthusiasm. Without our friends and associates, this project would still be a pipe dream. Don Blair, Bill Camacho, Tony Corbell, Terry Deglau, James Fidelibus, Don Gerhardt, Andy Marcus, Mark Roberts, and Steve Sheanin all played extremely influential roles.

On the corporate side, where would our profession, let alone photography, be without Eastman Kodak's support? Time and time again Kodak has created outstanding products and has sponsored thousands of seminars, all designed to stimulate our creativity as photographers. Every image in this book was photographed on Kodak products. Art Leather has also been a powerhouse of support for professional photographers. The Montage software and the Image Box are proof they not only believe in our profession, but put their money where their mouth is!

Hasselblad and Canon products are the preferred combination of equipment for so many photographers. Hasselblad's uncompromising quality and Canon's dedication to speed and accuracy helped to create our foundation of outstanding images.

A special thanks to Tim Burman, master black-and-white printer, whose work can be seen throughout this book.

Professional Photographers of America and WPPI have repeatedly exposed us to new ideas and techniques and given so many of us venues to express new concepts.

Last but not least, ninety percent of the images in this book were taken at real weddings. To all our brides and grooms, thank you all for allowing us to share some of your precious moments.

HASSELBLAD 503CW, 100MM CF LENS, f4.0 AT 1/250, KODAK PORTRA 400NC

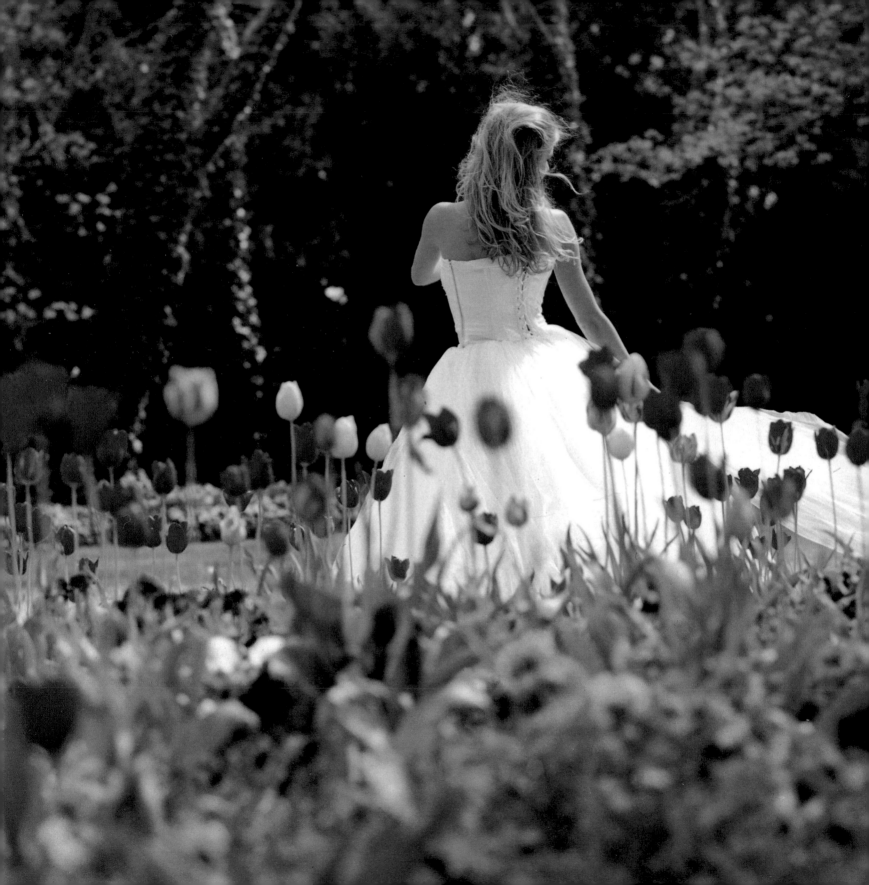

INTRODUCTION

As Bambi tells it, her decision to become a wedding photographer rose from a deep disappointment with her own wedding photographs. She'd made the worst choice in a photographer: a good friend who was purely amateur, the only one she knew who owned a slightly better than average camera. Bambi was so bogged down by the details of the wedding that she failed to realize she'd compromised the single most important part—the album—to a friend with a hundred-dollar camera. The images were, of course, disappointing, but they inspired in her a deep appreciation for recording family history. It was then that she decided to become a wedding photographer, to help people understand the importance of capturing the spirit of a wedding in one single collection of memories: the wedding album.

Every wedding is an opportunity to document the human experience and the personalities of two unique families coming together.

Like Bambi, most newlyweds fail to appreciate the importance of the wedding album until years after their wedding. At the same time, few photographers understand the incredible responsibility of capturing every emotion of a wedding day. Put these two together and you get album after album that look essentially alike, each filled with standard poses and lighting and few capturing the uniqueness of a particular wedding.

A wedding album isn't just a collection of photographs taken of an event. It's the first documentation of a brand new family; it's a couple's very first heirloom. If done properly, it will be handed down from generation to generation. Long after the food has been consumed, the flowers thrown away, the wedding gown put into storage, and the band paid, the wedding album will remain.

Bambi has made a career out of giving her clients the wedding albums of their dreams. She does this by understanding her target clientele and changing her style accordingly, by paying attention to the details, and by overcoming challenges with nontraditional techniques. No two weddings are alike, each offering her a new opportunity to document the human experience and the personalities of two unique families coming together.

Together, Bambi and I are going to show you how to abandon outdated rules of wedding photography to create contemporary images that capture the magic of the wedding day. We'll show you how to understand what today's clients want, and to go beyond their expectations. Faced with a drab, ugly wedding locale? We'll show you how to take images anywhere that will look like they were taken at the Ritz. Need to take formals of a large wedding party? Let's forget the standard poses and take group shots that have a flair for fashion. And all along, we'll talk about capturing the "decisive moments" that make each wedding unique.

The pose and even the look of this room is right out of a fashion magazine. The bride, and more importantly her friends, who will be future clients, loved this image because it was so out of the ordinary.

CANON EOS 1N, 85MM f1.2 LENS, f1.2 AT 1/60, KODAK T-MAX 400

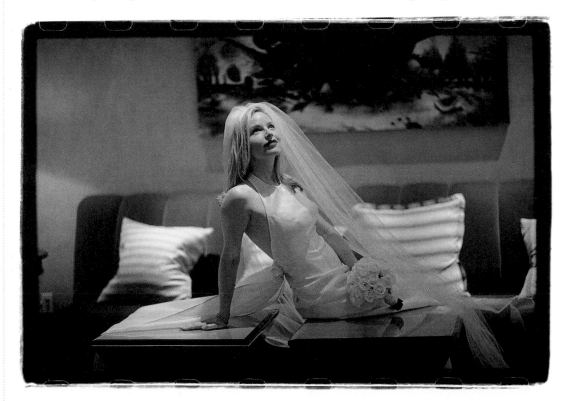

UNDERSTANDING YOUR CLIENTELE

Wedding photography isn't about taking photographs, it's about people. It's about capturing memories, and then presenting them to your clients. If you don't know or understand who your target client is, you'll never get your business off the ground. When Bambi started she thought people hired photographers based purely on price. She never took the time to understand the type of client she wanted to attract or which members of the wedding group she needed to influence most.

The bride should be your primary focus (although more and more, decisions about photography are being shared by the couple), followed by the mother of the bride. To understand what they want, you need to literally see the world through their eyes. We're talking about identifying your target customers, putting yourself in their shoes. Only then can you start to build a marketing plan with strategies for attracting them.

Want to get inside the heads of your target clients? Just pick up a few magazines! There's nothing to read, nothing to memorize, no numbers to call or trips to the library. If your target audience is brides, then you'll find the answers in any magazine read by young women, and we're not talking about only *Modern Bride,* but also *Vogue, Cosmopolitan, Martha Stewart Living,* and so on. Look at the portrait photography used in the ads. Notice any trends? Are most of the images soft-focus or tack-sharp? Are the compositions simple or complex? Is the photography more traditional or photojournalistic? Color or black and white? Look at the lighting, the exposure, the depth of field. Notice the clothing being advertised. Are the current styles brightly colored or more muted?

Now close the magazine and take a trip to the mall. Yes, we're going shopping, but you won't have to spend a cent. All you have to do is visit every store in the mall where young women shop. Pay attention to this year's colors, to the music playing in the background, to the merchandising, and especially to the "attitude" in the air. Got the idea?

Consumer demand and buying trends are influenced by the environment and "noise" in consumers' lives; this is what we call "Cantrell 101." Bambi's success is based purely on listening and watching consumer trends. She sees the world around her and boils it down to identify just what today's clients want. Then she offers them exactly what they want to buy. And more importantly, she uses the information to market herself as a "designer label." In other words, she taps into current trends to create a demand for her photography that parallels the mystique around Calvin Klein jeans, Polo shirts, and Coach, to name a few.

Once you've done your homework, think about the trends you discovered and how they relate to your photographic style. Do you keep yourself on the edge? Are you ready to adapt whenever you see a change in style coming? Most importantly, do you understand what your target clients want?

See the world through your clients' eyes, then give them what they want to buy.

THE ENGAGEMENT PORTRAIT

Once you understand the styles and buying trends of your target clientele as a whole, the next step is to further tailor your style for each individual client. Some couples will no doubt be more traditional in their aesthetic preferences, some more experimental, and so on.

There's no better way to get to know a couple than by doing an engagement shoot. From a purely business standpoint, an engagement session is an easy addition to the complete wedding package. But the real advantage is the opportunity it offers to get to know the bride and groom.

Bambi has almost as much fun on an engagement shoot as she does on the day of the wedding. It's a completely stress-free event. Because she lives in the San Francisco area she does a lot of these sessions on the beach, but in every community there are locations ideal for creating fun images of the bride and groom. The vast majority of her clients just want an informal image that captures the essence of who they are as a couple.

Think about the potential here to interact with your clients. You can either sit in a formal office environment asking them specific questions about the kinds of images they would like to see, important family members to shoot, and so on, or you can get the same information in a much more relaxed environment. The social time of an engagement session can be used to find out how the bride and groom met, where they're going on their honeymoon, and what their interests are, both individually and as a couple. By knowing your clients better, you almost guarantee being able to successfully meet their mindset on the wedding day. And don't forget, the session also helps clients get to know you and build the necessary trust and confidence in you as their photographer. It's a no-brainer!

RIGHT: Something as simple as a gate in the background can add an architectural flair to an image. HASSELBLAD 503CW, 100MM CF LENS, f8 AT 1/250, KODAK PORTRA 400VC

FAR RIGHT: This couple was more avant-garde, so cross-processing was used for a nontraditional portrait. (See page 84 for cross-processing techniques.) HASSELBLAD 503CW, 100MM CF LENS, f5.6 AT 1/125, KODAK EKTACHROME 100VS

PHOTOJOURNALISM: CAPTURING THE HEARTBEAT OF A WEDDING

The single most important trend in today's wedding photography market is photojournalism. Photojournalism, by definition, is simply documenting an event without interfering or influencing the images. This is as opposed to traditional portraiture, which requires the photographer to be hands-on and to direct the subjects in creating each image.

Wedding photojournalism is absolutely hands-off. It's about taking the emotion of the day, the intangible, and catching it on film without making it happen. Traditional portraiture still has a place in documenting weddings, but the best photographer will understand which style is preferred by the bride and groom and balance the mix accordingly. Gone are the days of checklist poses and an hour of posed images before the reception. And while most clients will still want at least a few formal images, even those can be done within a minimum amount of time and still capture the personality and pure excitement of the wedding day.

Denis Reggie, considered by many wedding photographers as the "father" of wedding photojournalism, has helped photographers understand the need to capture the *decisive moment*. Decisive moments are those split-second details, expressions, mannerisms, and interactions that make each subject unique. You must push the shutter button at just the right moment to capture the emotion and essence of your subject.

Wedding photojournalists must be not only invisible, but skilled in anticipating each decisive moment. To do this, start as early in the day as you possibly can and observe everything. Keep asking yourself, "What makes this wedding different from the others?" Here's a little exercise Bambi used early on: If you've photographed a wedding before, get the video from the last wedding you shot and see what you missed. It's all about capturing the emotion of the day at exactly the right time, and the opportunities are endless.

Professional wedding photographers have only one responsibility: to record one of the most important events in their subjects' lives. As such, never worry about how much film you're using. Bambi typically shoots more than a thousand photographs per wedding! Your goal should be to take lots and lots of both black-and-white and color shots, then let your client choose. (Are you going to worry about them buying more than anticipated? Of course not!) Look at the big picture: How many people are going to feel the impact of the photographs? How many potential clients might see the wedding album and hire you as a result? It's not worth missing that one decisive moment because you were afraid of wasting film.

YOUR **FILM CHOICES** THROUGHOUT THE DAY SHOULD REFLECT THE MOOD YOU'RE TRYING TO CAPTURE, AS WELL AS THE CLIENTS' PREFERENCES (WHICH SHOULD HAVE BEEN DISCUSSED BEFOREHAND). A HIGHER-SPEED BLACK-AND-WHITE FILM IS PERFECT FOR THE HOURS OF PREPARATION JUST BEFORE THE WEDDING. IT ALLOWS YOU TO FOCUS ON THE EMOTION AND AVOID BEING DISTRACTED BY OTHER COLORS IN THE ROOM. BLACK-AND-WHITE FILM ALSO ALLOWS EACH PERSON TO INTERPRET THE FINAL IMAGE IN HIS OR HER OWN WAY, AS THERE'S NOTHING DRAWING THE EYE AWAY FROM THE EMOTION OF THE SCENE. THE TIME TO LOAD COLOR FILM IS WHEN YOU'RE PHOTOGRAPHING FORMAL PORTRAITS, THE FLOWERS, THE GOWNS, AND LOCATION SHOTS OF WHERE THE WEDDING WAS HELD.

WHILE MANY OF BAMBI'S ALBUMS ARE DOMINATED BY COLOR IMAGES, WHICH SUPPORT THE EXPECTATIONS OF THE MORE TRADITIONAL FAMILY MEMBERS, THE REAL EMOTION OF THE DAY WILL OFTEN BE CAPTURED IN BLACK AND WHITE. DON'T UNDERESTIMATE THE IMPORTANCE OF BLACK-AND-WHITE IMAGES FOR TODAY'S MARKET—BLACK AND WHITE IS HOT!

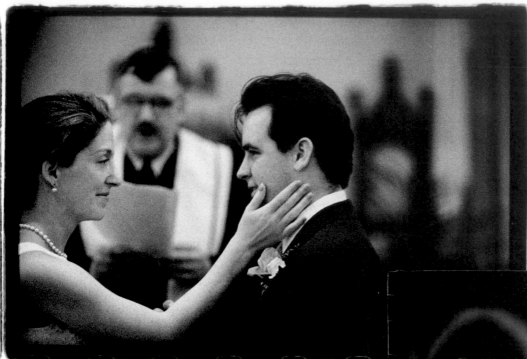

*It's all about
taking the emotion
of the day,
the intangible,
and catching it
on film.*

Prefocusing allows you to capture unexpected moments in the ceremony. Also, shooting with a large aperture lets you hone in on the magic.

CANON EOS 1N, 85MM f1.2 LENS, f1.2 AT 1/60, KODAK T-MAX P3200 RATED AT 1600

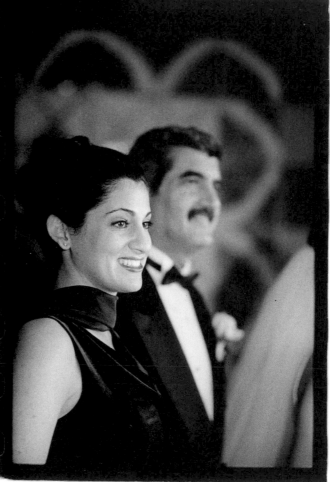

A decisive moment might be during the formal photographs when a bridesmaid relaxes and gives you that one true smile.

CANON EOS 1N, 85MM f1.2 LENS, f1.2 AT 1/60, KODAK T-MAX P3200 RATED AT 1600

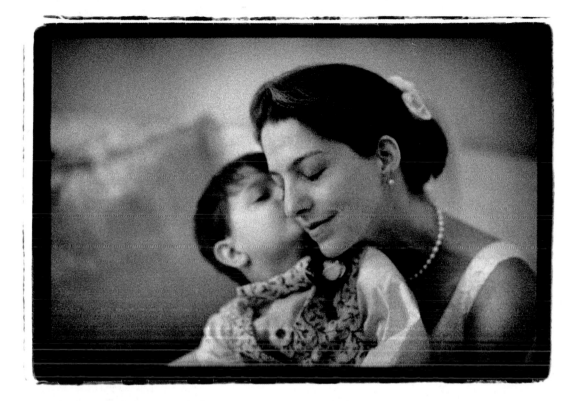

Don't be a slave to everything you've learned about composition. The pure portraitist would have wasted time fixing the boutonniere, in the end missing the moment.

CANON EOS 1N, 85MM f1.2 LENS, f1.2 AT 1/60, KODAK T-MAX P3200 RATED AT 1600

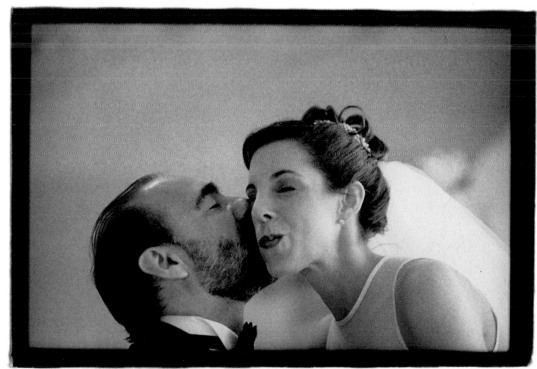

CANON EOS 1N, 85MM f1.2 LENS, f5.6 AT 1/125, KODAK T-MAX P3200 RATED AT 1600

Sheer excitement!

CANON EOS 1N, 85MM f1.2 LENS, f2.0 AT 1/60, KODAK T-MAX P3200 RATED AT 1600

BEING PREPARED

Remember Murphy's Law? Well, Murphy was an optimist! Wedding photographers get only one chance to capture the magic of a wedding and there are an infinite number of things that can go wrong. It's critical to carefully consider any factor you can anticipate in advance.

The site. Always check out the wedding site at least one week before the event. Look for areas with backgrounds you can use for formal images, so whatever time you spend doing them can be used efficiently. Also look for alternate areas to use in case of inclement weather. And don't forget to factor in the time of the wedding. Creating images at an indoor wedding in the evening will be completely different from taking them at an outdoor wedding in the afternoon.

The weather. Check the weather report. If there's rain in the forecast, bring a decent umbrella and be prepared to protect your camera gear. Again, you've got to be ready for anything.

Your equipment. It's imperative that, as a professional, you always have adequate backup equipment. Make sure you have at least one additional camera body, two to three additional lenses, and a backup strobe.

Hiring an assistant. Having an assistant will add a lot to your creative flexibility. A good assistant can change film, move lights, and help you keep track of where the emotion is taking place. If you decide to hire an assistant, no matter how good, train him or her to know exactly what you expect. If you've taken the time to do the training, a top-notch assistant will become your second set of eyes, not just a pair of hands to help carry your gear.

Learn to sense the anticipation from everyone, not just the bride and groom.

CANON EOS 1N, 85MM f1.2 LENS, f5.6 AT 1/125, KODAK T-MAX 400

19

No guy ever played "groom" as a kid, but many women played "bride," and the most important day of her life starts hours before she actually walks down the aisle. A wedding is an event driven entirely by emotion. It is all about the excitement, which starts when the bride, most often at her family's home, starts to prepare for the big event.

The most important day of a bride's life starts hours before she walks down the aisle.

Arrive at the bride's house early, typically three to four hours before the wedding. Set the time in advance with the bride and be punctual—you don't want to add to the stress of the day by making her worry about your being a no-show. If you're a woman, you'll most likely be welcome to join the bride in the dressing room while she gets ready. It's a little more complicated if you're a guy, making it even more important to communicate effectively with the bride beforehand. If you sense she's going to be uncomfortable with you in the room, hire a female assistant to get the shots. If you can't afford the assistant, you'll have to simply play it by ear.

THE **CANON EOS 1N** WITH AN 85MM F1.2 LENS IS GREAT FOR SHOOTING THE BRIDE'S PREPARATION. THE CANON'S BIG ADVANTAGE IS THE F1.2 LENS, WHICH ISN'T AVAILABLE FOR MEDIUM-FORMAT CAMERAS LIKE THE HASSELBLAD. WHEN USED WITH A WIDE APERTURE, THE F1.2 LENS WORKS TO DRAMATICALLY NARROW THE DEPTH OF FIELD AND BLUR THE BACKGROUND. THIS MAKES IT IDEAL FOR SHOOTING AT THE BRIDE'S HOME, WHERE THE BACKGROUND IS OFTEN FILLED WITH KNICKKNACKS AS WELL AS BAGS, SHOEBOXES, AND TRASH FROM THE WEDDING DAY ITSELF. AT THIS POINT IN THE DAY BAMBI USES THE CANON WITHOUT A FLASH AND WITH BLACK-AND-WHITE FILM ONLY (SEE PAGE 26).

To shoot this period effectively, put yourself in the bride's shoes. She's worried about everything going right. Will she look like the bride in the picture she showed her hairdresser? Did the bridesmaids pick up their dresses on time? Did the best man return the groom in good shape after the bachelor party? Will everyone have a good time at the reception? If the parents are divorced, which, sadly, is too often the case, will Mom and Dad get along? The list of things the bride is worrying about is endless, so it's important to simply stay out of her way and look for the magical moments.

Remember, every bridal portrait doesn't have to look the same. Whether or not you choose to take formal portraits at the bride's house before the wedding (see page 68), learn to find formal images at informal moments. Being a photojournalist means capturing the mood, instead of trying to direct it yourself, and that may be all you need to create the father of the bride's most cherished image.

 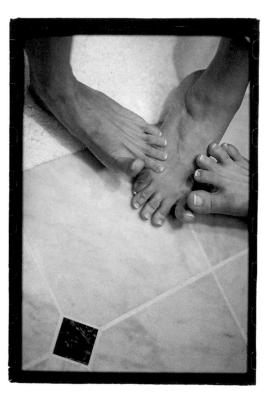

Don't be afraid to follow the bride to the salon, where the interaction between the bride and her friends will be jammed with emotion.

CANON EOS 1N, 85MM f1.2 LENS, f5.6 AT 1/125, KODAK T-MAX 400

Pay attention to every detail. A French pedicure became the "pre-game" highlight for this bride and her two best friends.

CANON EOS 1N, 85MM f1.2 LENS, f2.0 AT 1/60, KODAK T-MAX 400

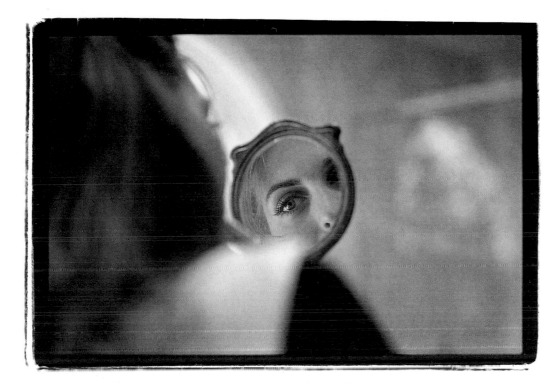

Whatever lens you're using, shoot with the widest aperture you can to isolate the magic in the image. During the makeup session, a shallow depth of field allows you to highlight unique features of the bride's face. This particular bride had extraordinary eyelashes.

CANON EOS 1N, 85MM f1.2 LENS, f2.0 AT 1/125, KODAK T-MAX P3200 RATED AT 1600

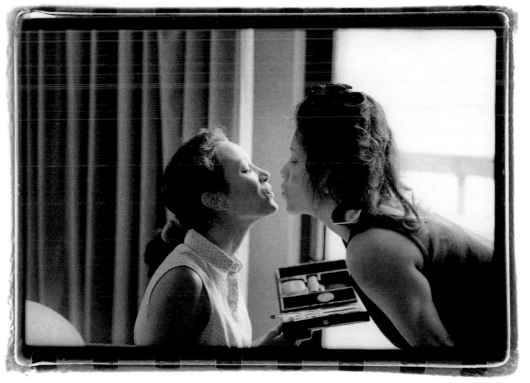

The period of preparation is a time of high emotion and excitement. Be prepared to catch the interaction between the bride and her friends and family.

CANON EOS 1N, 85MM f1.2 LENS, f3.5 AT 1/60, KODAK T-MAX 400

One difference between a great photographer and one who's only average is an ability to capture the details. There's no such thing as too many detail shots before the wedding. Hundreds of little nuances make each wedding unique and help build the story of a new family. Capturing such details shows that you're in tune with the bride and groom and the importance of the day.

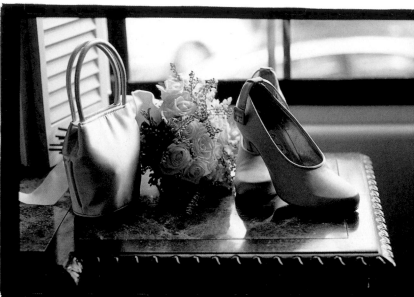

Don't be afraid to style a few of your own creations. Here, window light helps set the perfect mood for some of the bride's most important accessories.
CANON EOS 1N, 85MM f1.2 LENS, f3.5 AT 1/60, KODAK T-MAX 400

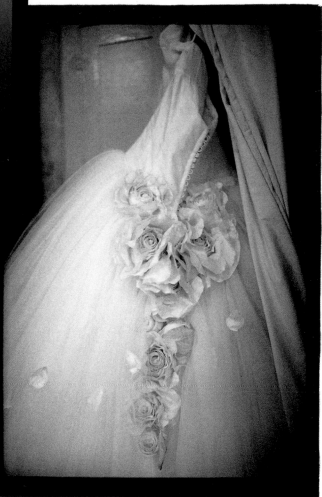

Pay attention to details. The dress is *always* important.
CANON EOS 1N, 85MM f1.2 LENS, f1.2 AT 1/60, KODAK T-MAX P3200 RATED AT 1600

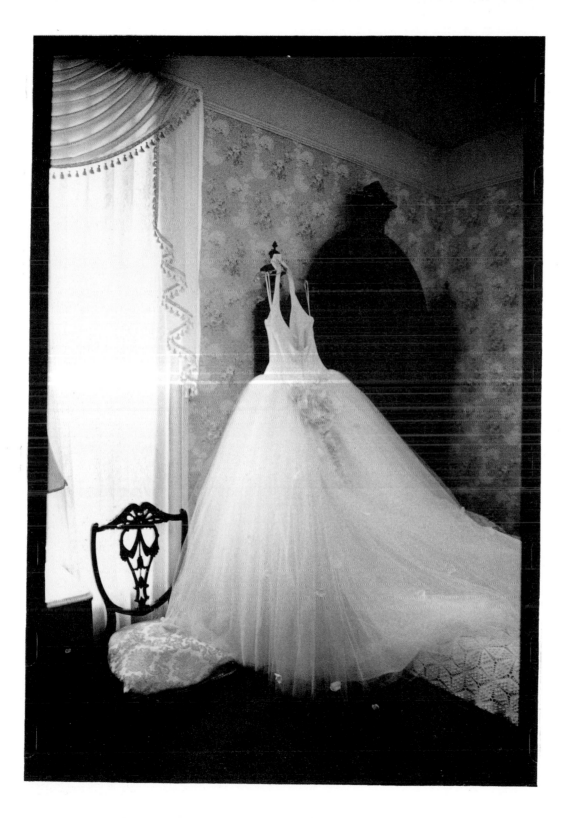

Window light adds a special sense of purity to what might otherwise be an ordinary image.

CANON EOS 1N, 85MM f1.2 LENS, f1.2 AT 1/60, KODAK T-MAX P3200 RATED AT 1600

When shooting black and white, Bambi uses Kodak's **T-Max** line of films. The 400-speed T-Max is her favorite. It has a tight grain structure that produces sharp blacks and whites, adding drama to your images. The 400 is also very forgiving; it can be pushed and pulled without compromising image quality.

Bambi also uses T-Max p3200, which she rates at 1600. Because of its large grain structure, this film gives images a romantic, fine-art look. The p3200 is ideal in low-light situations when you don't want to lose the moment with the pop of a strobe. The period of preparation, for example, is the perfect time to leave off the flash and simply shoot available light.

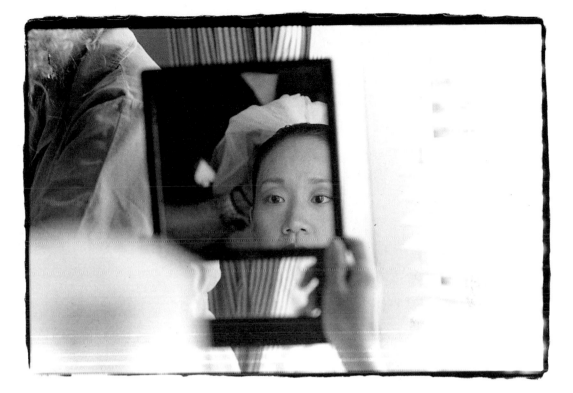

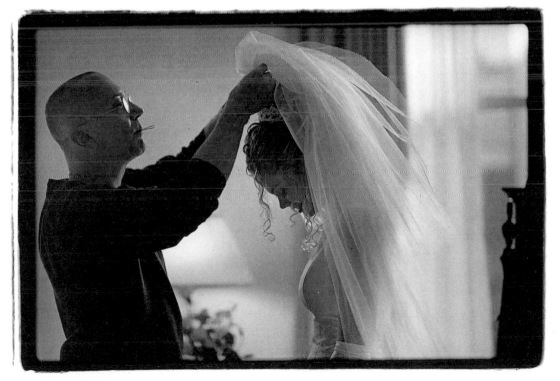

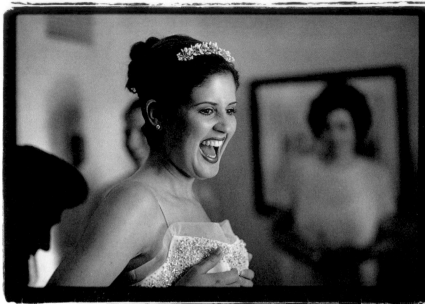

A good wedding photographer captures the magical moments without being a noticeable intrusion. Move quickly, be in tune with the bride, and try to anticipate each significant photographic opportunity.

CANON EOS 1N, 85MM f1.2 LENS, f1.2 AT
1/60, KODAK T-MAX 400

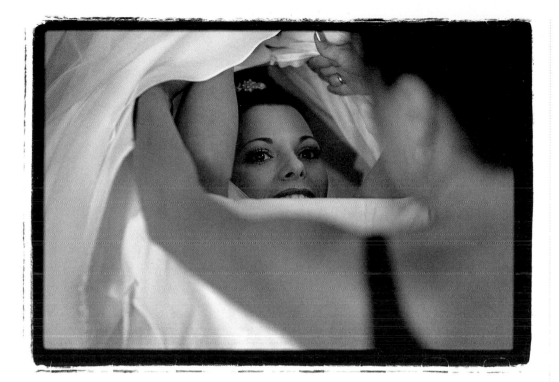

TOO MANY PHOTOGRAPHERS TAKE THE EASY WAY OUT AND PHOTOGRAPH AN ENTIRE WEDDING AT F8.0 1/125 WITH ONLY ONE LENS. WELL, IT'S NOT SO EASY TO GET YOUR CLIENT TO PURCHASE ADDITIONAL IMAGES WHEN EVERYTHING LOOKS THE SAME. TRY PUSHING THOSE LENSES OF YOURS TO THE MAX AND SHOOT WIDE OPEN, AS WAS DONE FOR SO MANY OF THE IMAGES IN THIS BOOK.

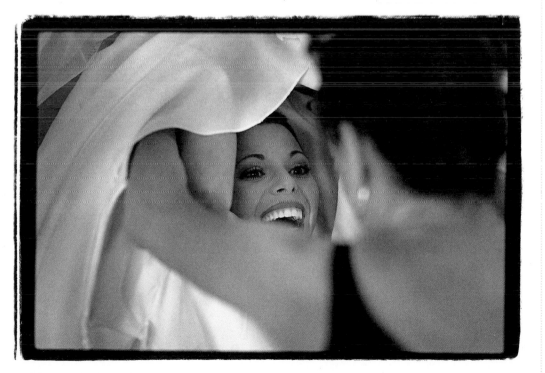

CANON EOS 1N, 85MM f1.2 LENS, f1.2 AT 1/60, KODAK T-MAX 400

PRINTING WITH **"SLOPPY" BOR-
DERS,** LIKE THOSE SHOWN HERE,
GIVES YOUR IMAGES A STRONGER
FINE-ART LOOK AND IS PURELY A
JUDGMENT CALL BASED ON THE
TASTE OF YOUR CLIENTS. IF YOU
WANT SLOPPY BORDERS, ASK THE
LAB TO PRINT THE IMAGES WITH
"FINE ART BORDERS." THEY'LL USE
A NEGATIVE CARRIER THAT'S BEEN
FILED SO AS TO PRINT THE IMAGE
FULL-FRAME AND SHOW THE EDGES
OF THE NEGATIVE.

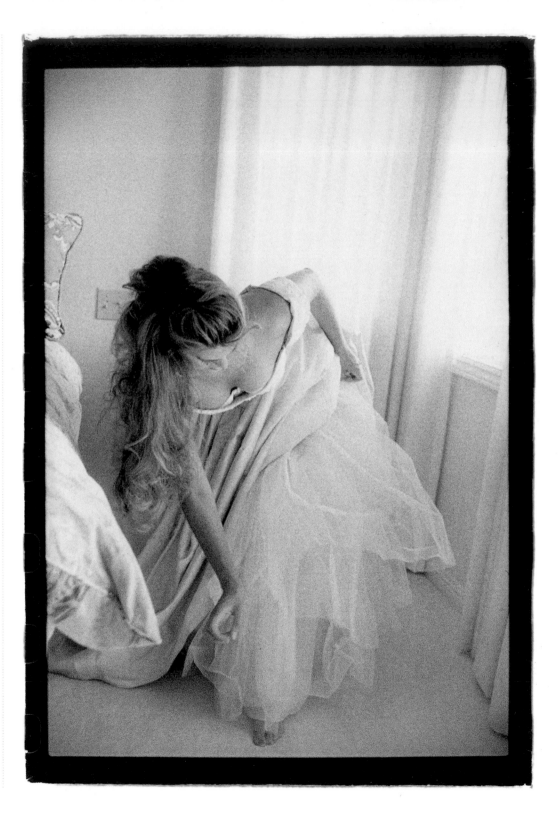

OPPOSITE: By using high-speed black-and-white film, Bambi avoided the distractions of the gold walls and printed bed skirt.

CANON EOS 1N, 85MM f1.2 LENS, f2.0 AT 1/125, KODAK T-MAX P3200 RATED AT 1600

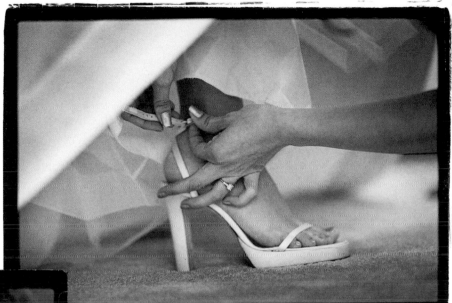

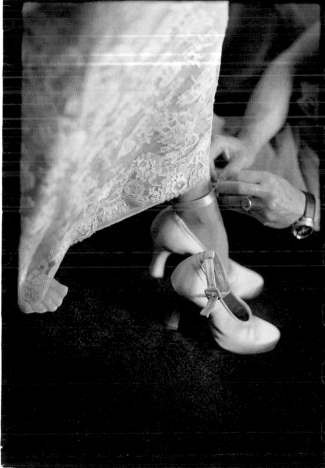

These aren't just any shoes: They were a wedding present from the groom. Shots like this will quickly establish you as a photographer in tune with the details important to the bride.

CANON EOS 1N, 85MM f1.2 LENS, f1.2 AT 1/60, KODAK T-MAX P3200 RATED AT 1600

Trust us: Most brides will spend six months looking for their wedding shoes, which no one will ever see. The shoes are very important.

CANON EOS 1N, 85MM f1.2 LENS, f2.0 AT 1/60, KODAK T-MAX 400

Just as the shoes were impor-
tant, the bride chose the dress
because she loved its back.
CANON EOS 1N, 85MM f1.2 LENS, f1.2 AT
1/60, KODAK T-MAX P3200 RATED AT 1600

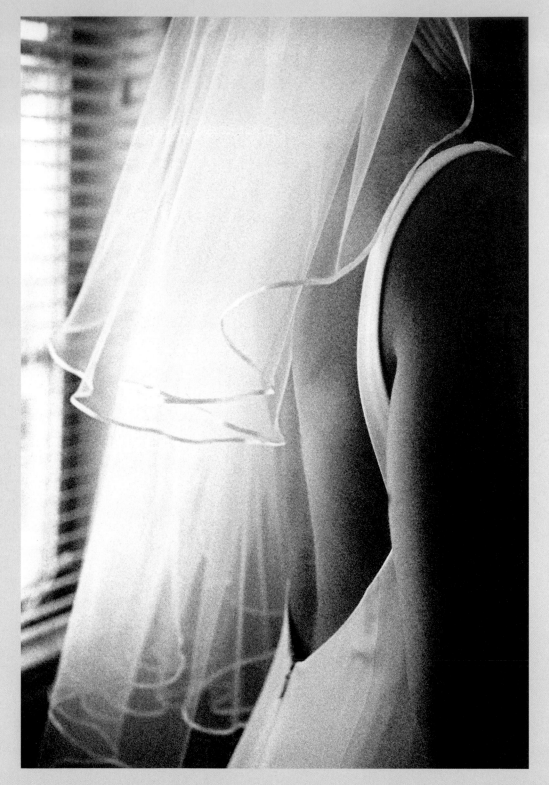

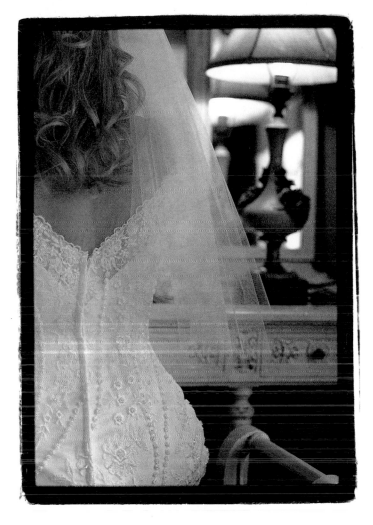

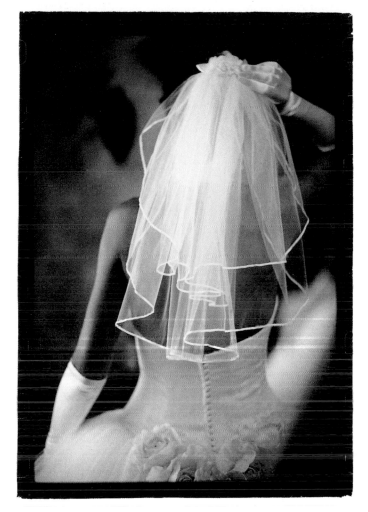

A bride will have the tiniest waist of her entire lifetime. As a bonus, you're also capturing details of the gown.

CANON EOS 1N, 85MM f1.2 LENS, f2.8 AT 1/60, KODAK T-MAX P3200 RATED AT 1600

It's all about the details. In this case, the veil, the dress, and the bride's waistline.

CANON EOS 1N, 85MM f1.2 LENS, f1.2 AT 1/60, KODAK T-MAX P3200 RATED AT 1600

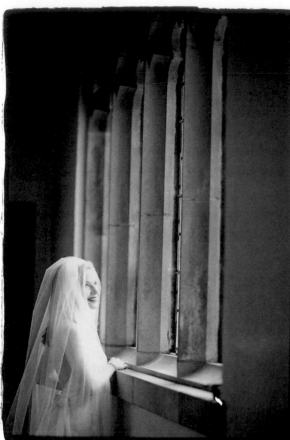

Learning to observe your subjects will allow you to find formal images at informal moments.
CANON EOS 1N, 85MM f1.2 LENS, f4.0 AT 1/60, KODAK T-MAX 400

Pay attention to body language and the natural flow of human experience.
CANON EOS 1N, 85MM f1.2 LENS, f2.0 AT 1/60, KODAK T-MAX P3200 RATED AT 1600

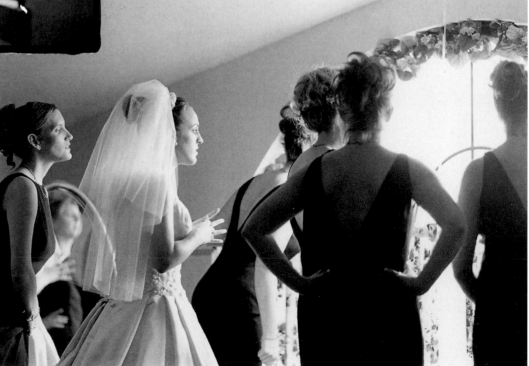

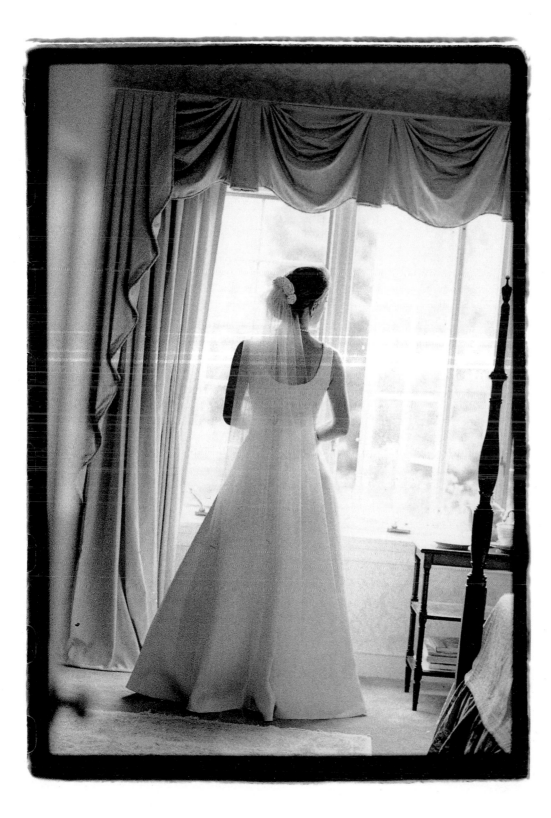

It's all about capturing the mood of the day. Again, this formal-seeming image was captured at an extremely informal moment: This nervous bride was smoking a cigarette!

CANON EOS 1N, 35–105MM ZOOM LENS, f3.5 AT 1/60, KODAK T-MAX P3200 RATED AT 1600

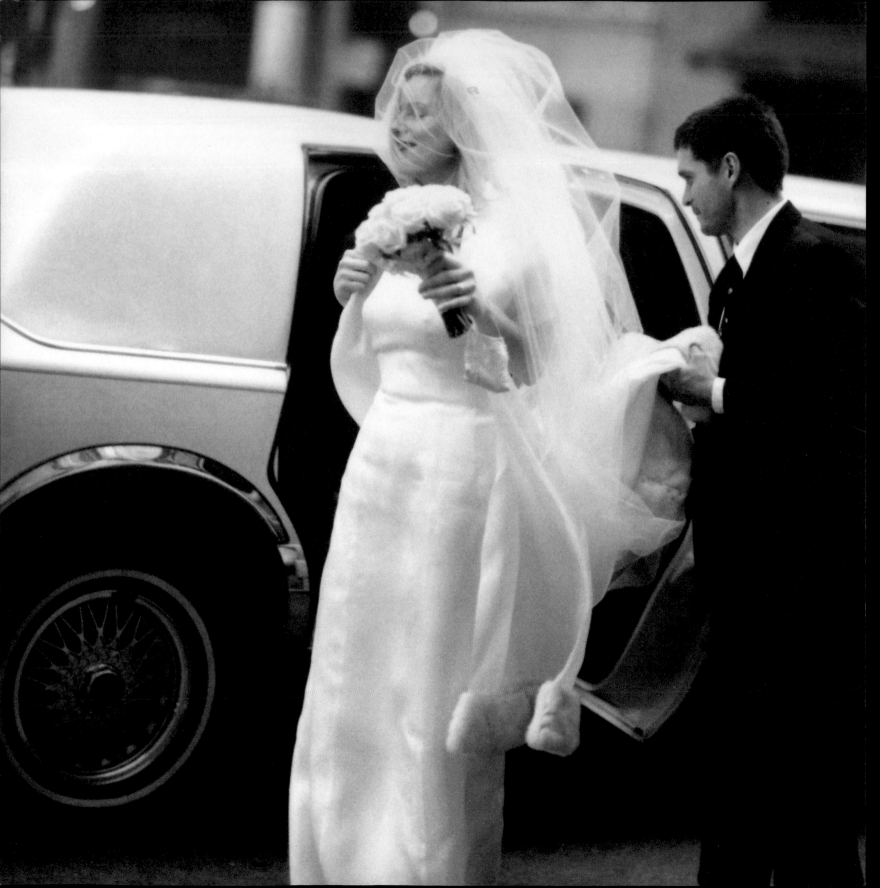

When it comes to shooting the ceremony, many photographers rely on the same standard, clichéd checklist of poses: the walk down the aisle, the bride and groom at the altar, the lighting of the unity candle, the ring exchange, the communion, and the kiss, just to name a few. But in fact, the ceremony is at the epicenter of the wedding day; it is filled with emotion and your goal is to document each priceless moment. So let's make it our challenge to capture images so unique they'll require a second album of *just* the ceremony. We're talking about using different locations, films, and lenses to pioneer images of such remarkable quality that we change the entire configuration of the album itself—something your clients, their families, and their future offspring will love.

Let's take images so unique they'll require a second album just for the ceremony.

SETTING THE SCENE

You should leave the bride's house about an hour before the wedding and head to the wedding site. If the timing works to capture images of her getting into the limousine, terrific. If not, don't worry about it. You'll have another opportunity to get her coming out of the limo at the wedding location.

The time before the ceremony is ideal for capturing the prewedding jitters of the groom, interaction between the groom and his groomsmen, and "scene-setters," or location shots, of the wedding site. Create a collection of images that add to the story, focusing on the details and telling more about the event itself.

When the bride arrives, have your camera ready; it's important to document her arrival. Pay attention when she starts getting out of the car and consider taking some shots from inside the car. Also, keep your eye on Mom and Dad, her maid of honor, and any other close friends or family members who may have ridden along with her.

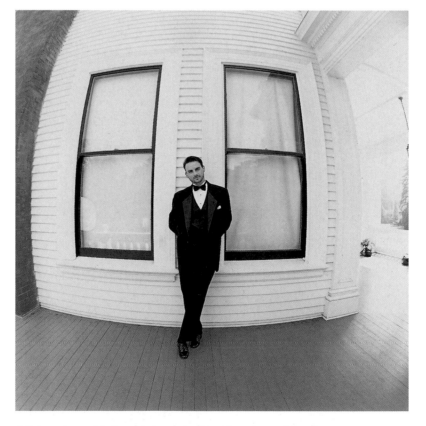

A fisheye lens adds formal drama to this otherwise ordinary image.

HASSELBLAD 503CW, 30MM CF FISHEYE LENS, f8.0 AT 1/250, KODAK T-MAX 400

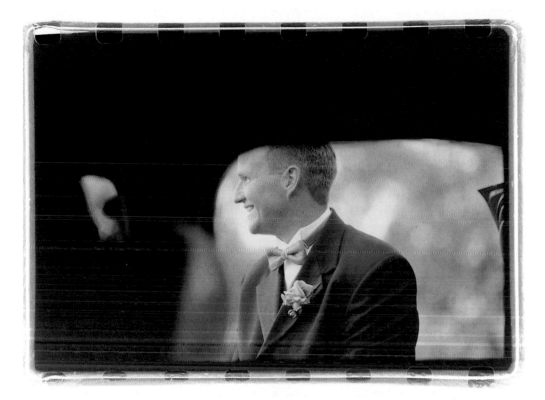

Don't forget the groom! Notice the impact of black-and-white film, and of taking the images from the other side of the car. The car door creates the perfect frame.

CANON EOS 1N, 85MM f1.2 LENS, f4.0 AT 1/60, KODAK I-MAX 400

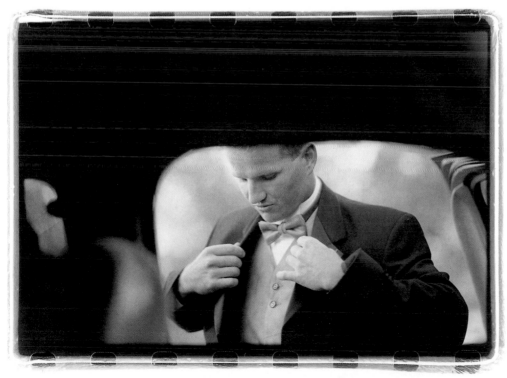

USING INFRARED FILM

One way to practically guarantee a high-impact image is to use infrared film, which produces a dramatic, illustrative look. Infrared is a soft film; it gives Caucasian complexions a wonderfully creamy, white texture. As with all of the more creative techniques, be careful not to use infrared film too much—just a few images go a long way.

Experiment with infrared well in advance of actually using it during a wedding. It will, for example, be rated differently in cold weather than in the heat of summer. Start rating it at 1600, then move to 800, 400, 200, and 100. At each step, bracket the test images until you're comfortable with the settings and results.

It's critical that infrared film be loaded and unloaded in complete darkness. A photo bag will work just fine. When working with a 35mm camera that has a film window showing the film canister through the back door, cover up the window with a little piece of duct tape to shut out any light leaks. Bambi prefers to shoot infrared in her Canon EOS 1N, but you'll note that in some cases she's used a Leica R4. This is simply because it's impractical to load and unload infrared while shooting a wedding, so she always brings a third camera (in these cases, a Leica R4) loaded with infrared and ready to go.

Always be careful not to let infrared film get hot. And last but not least, you must use a filter on the front of the lens; Bambi recommends a 29B filter.

This isn't just a photograph of the front of the church but a "wow" print taken with infrared film.

LEICA R4, 50MM f2.0 LENS, f4.0 AT 1/60, KODAK HIGH-SPEED INFRARED RATED AT 200

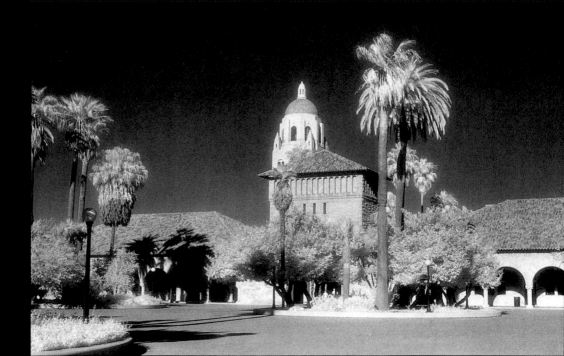

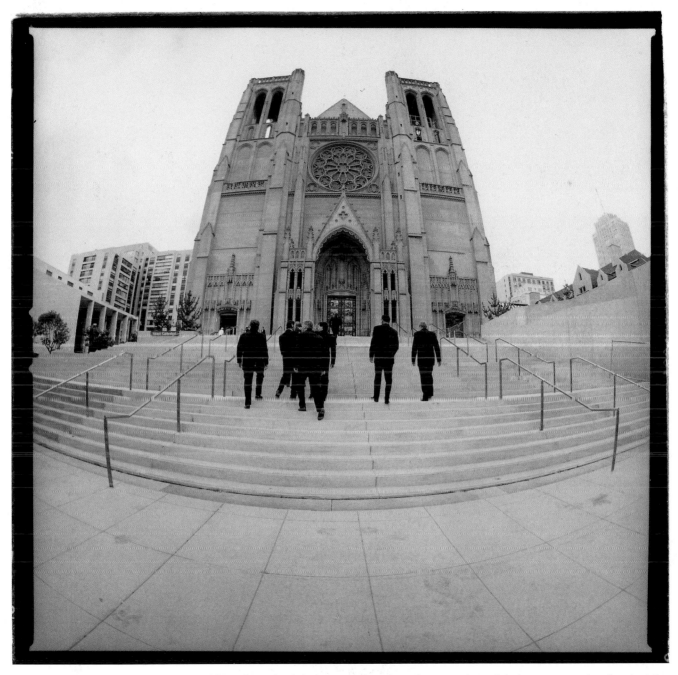

Scene-setters are critical to a great wedding album. Look for ways to document the event that might be more creative than just the typical shots of the front of the building, the flowers, or the invitation. This scene-setter of the church was made more meaningful by including some of the groomsmen as they entered.

HASSELBLAD 503CW, 30MM CF FISHEYE LENS, f5.6 AT 1/125, KODAK T-MAX 400

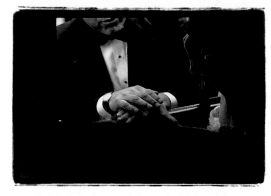

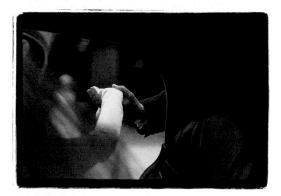

The bride's arrival. You can almost feel Dad patting his daughter's hand. It's only by not worrying about how much film you're using that you can capture unique moments like this one, just before a father and daughter's life changes forever.

CANON EOS 1N, 85MM f1.2 LENS, f3.5 AT 1/60, KODAK T-MAX 400

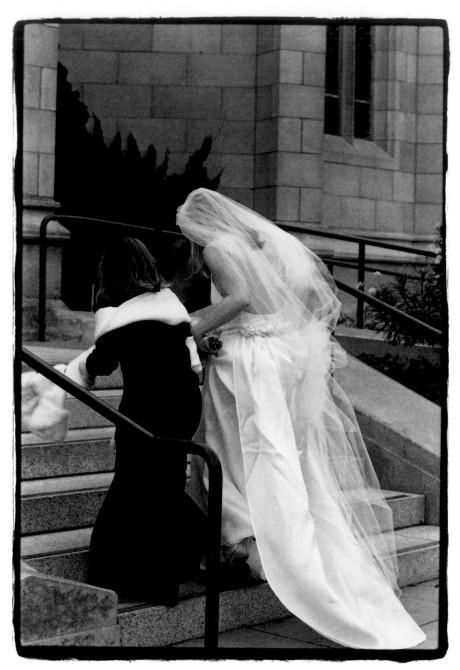

CANON EOS 1N, 85MM f1.2 LENS, f5.6 AT 1/60, KODAK T-MAX 400

Hand-Coloring

You don't want to convert a black-and-white image into a color photograph, but you can give it extra impact by adding just a bit of color by hand. Kodak Retouching Colors are a personal favorite, and if you can color like a five-year-old you can use them.

To activate the color, just breathe on the dye in the canister. Then take a cotton swab or small brush and transfer some color to the photograph. Make sure you keep the color simple and subtle. Once you're happy with the results, set the dye by breathing on the photograph. Just be careful not to spit on your print!

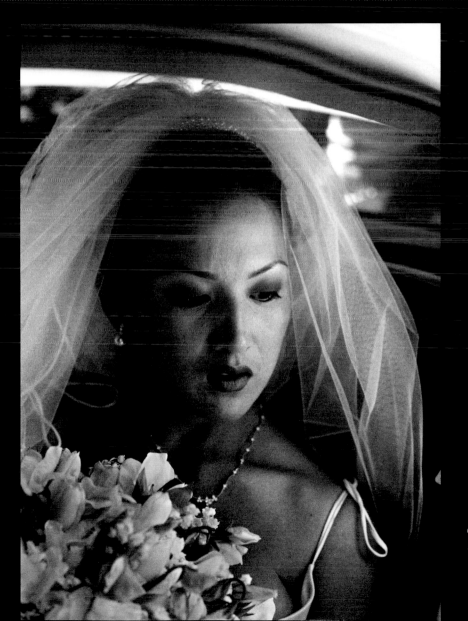

CANON EOS 1N, 85MM f1.2 LENS, f5.6 AT

1/60, KODAK T-MAX 400

CAPTURING SPECIAL CUSTOMS

Almost every wedding incorporates rituals specific to a particular denomination or culture. In most Jewish weddings, the bride and groom see each other before the ceremony during the signing of the *Ketubah,* a traditional marriage document. In Philippine weddings, the veil ceremony is similarly important. Rituals like these are stories within the story of the day and can only be captured through the eyes of a photojournalist.

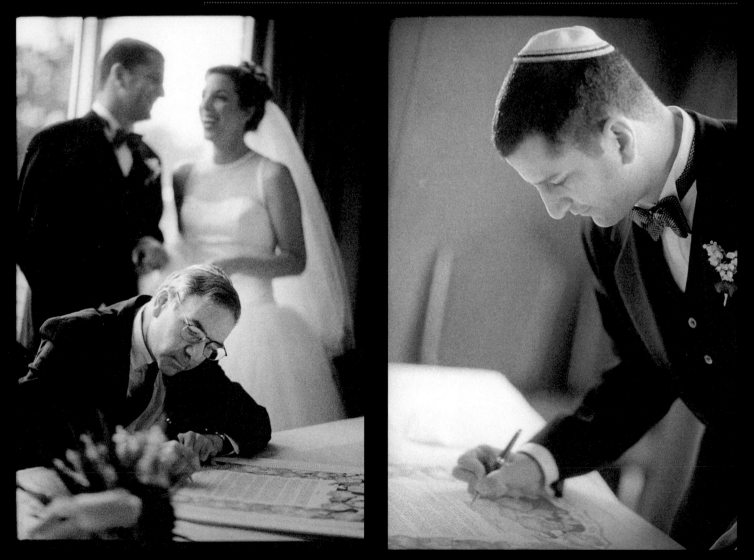

The signing of the *Ketubah* is a centuries-old tradition in Jewish weddings.

CANON EOS 1N, 85MM f1.2 LENS, f2.0 AT 1/60, KODAK T-MAX P3200 RATED AT 1600

WALKING DOWN THE AISLE

The best way to approach this part of the wedding is to use two cameras. Set one on a tripod by the altar, either with an assistant or for you to use with a wireless remote (such as the one provided with the Hasselblad 503CW); this camera will be used to photograph the wedding processional from the front. Keep the second camera with you as you hang back with the bride and her father and/or mother to capture those intense final minutes before the ceremony.

It's important to photograph every person who walks down the aisle. Photograph from the waist up to capture both the event and his or her facial expressions. It's also important to notice the action taking place elsewhere in the room; this is an ideal time to capture images of family and friends as they watch the bride. The looks on people's faces as they see her for the first time will only be captured by you. The bride will never notice or remember how people reacted until you present those memories to her.

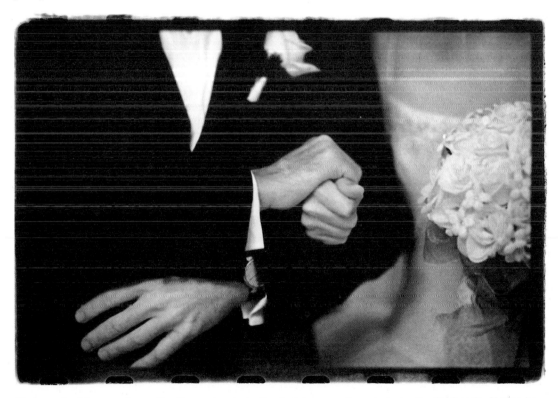

It's important to pay close attention not only to the facial expressions, but also to the hands. Notice how tightly Dad is holding his daughter's hand as they walk down the aisle.

CANON EOS 1N, 85MM f1.2 LENS, f2.0 AT 1/60, KODAK T-MAX P3200 RATED AT 1600

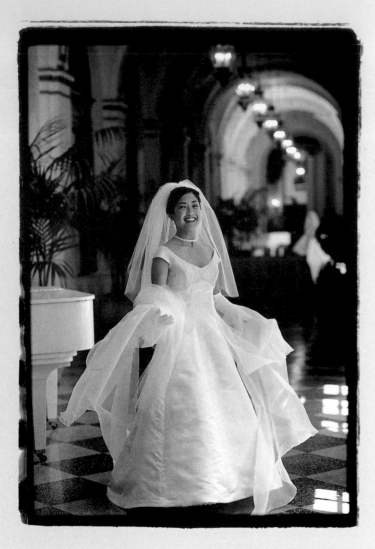

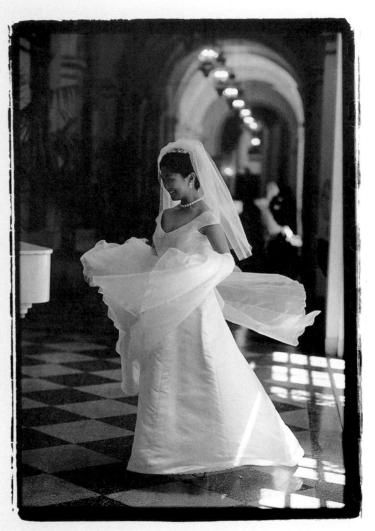

At almost every wedding the photographer has a moment alone with the bride just before the ceremony. This is a day she's dreamed about since she was a little girl. Just asking a nervous bride to take a quick spin in her gown creates a moment guaranteed to make everyone smile!

CANON EOS 1N, 85MM f1.2 LENS, f5.6 AT 1/125, KODAK T-MAX 400

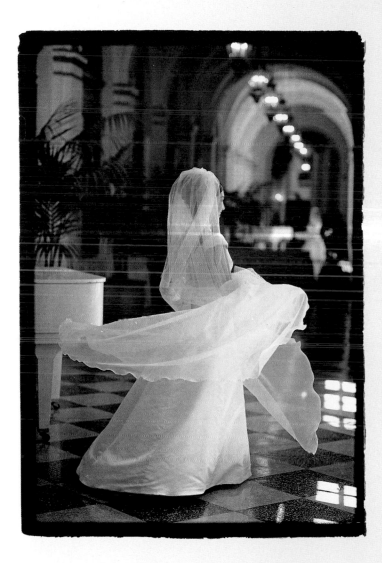

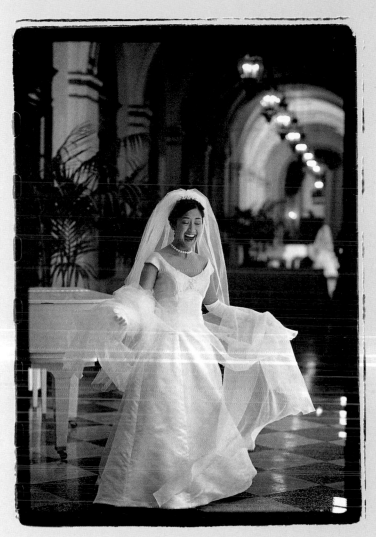

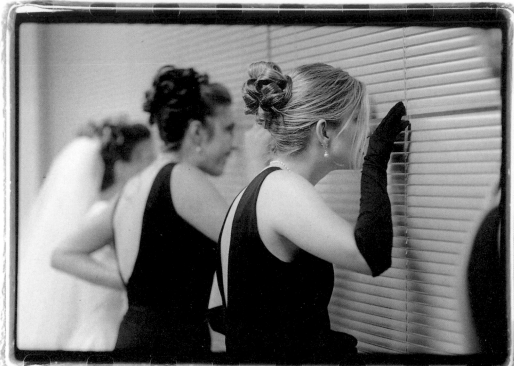

You don't need to see the faces of the bridesmaids to capture the excitement as they sneak peeks at the groom and groomsmen for the first time.

CANON EOS 1N, 85MM f1.2 LENS, f2.8 AT 1/60, KODAK T-MAX 400

You can almost feel the lump in Dad's throat as he's about to walk his daughter down the aisle.

CANON EOS 1N, 85MM f1.2 LENS, f2.0 AT 1/125, KODAK T-MAX P3200 RATED AT 1600

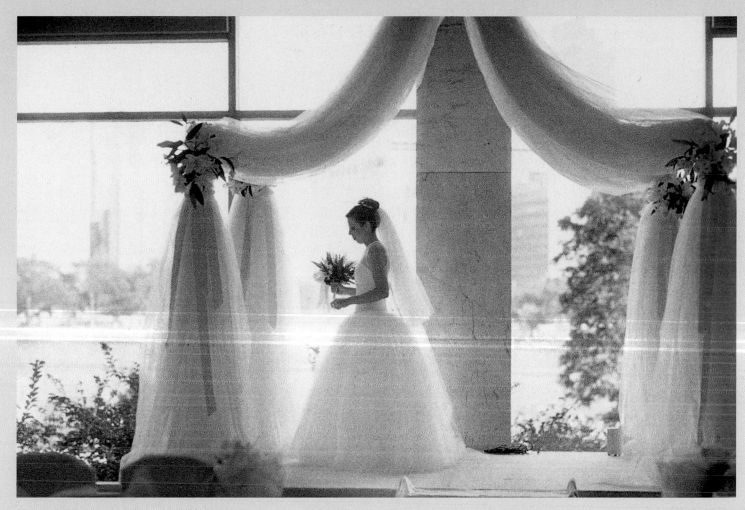

The wonderful nervousness of a bride just before the ceremony.

CANON EOS 1N, 85MM f1.2 LENS, f2.0 AT 1/60, KODAK T-MAX P3200 RATED AT 1600

These tight shots of the groom's face as he waits for his bride and then sees her for the first time say it all.

CANON EOS 1N, 85MM f1.2 LENS, f2.0 AT 1/60, KODAK T-MAX P3200 RATED AT 1600

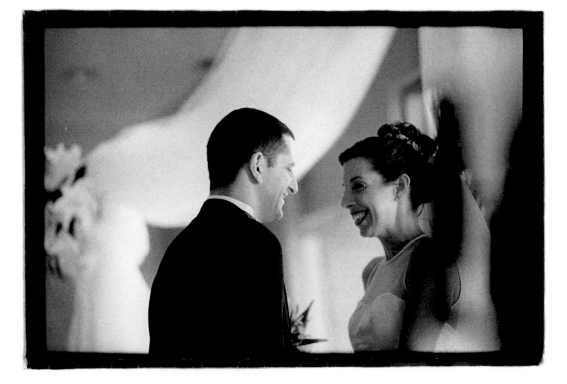

With this image of the bride and groom together just before the ceremony, the photojournalist has documented one of the most emotional moments of the day.

CANON EOS 1N, 85MM f1.2 LENS, f1.2 AT 1/60, KODAK T-MAX P3200 RATED AT 1600

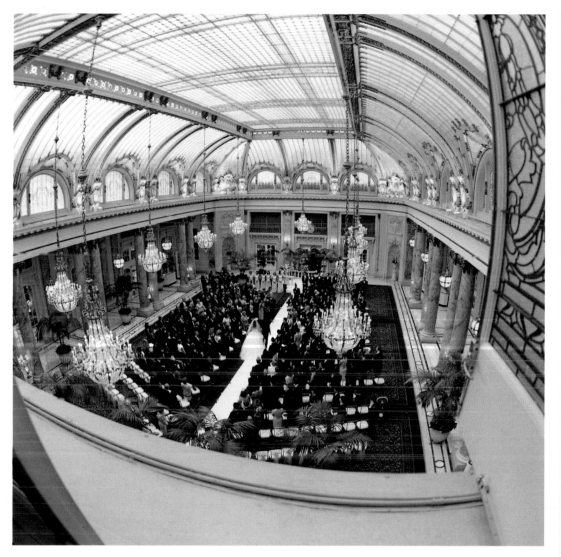

KODAK'S **PORTRA** FAMILY OF FILMS IS BAMBI'S FAVORITE FOR SHOOTING COLOR. THE FILM COMES IN 160, 400, AND 800 SPEEDS, WITH THE 160 AND 400 AVAILABLE AS EITHER "NC" (FOR "NATURAL COLOR") OR "VC" (FOR "VIVID COLOR"). THE NC FILMS ARE SOFTER AND BETTER FOR SKIN TONES WHILE THE VC FILMS ARE SHARPER, WITH HIGHER CONTRAST. ALL OF THE PORTRA FILMS ARE VERY ACCURATE; SET YOUR LIGHT METER AT 160 FOR THE 160 SPEED FILM, 400 FOR THE 400-SPEED, AND SO ON.

ONE OF THE BEST THINGS ABOUT THE PORTRA LINE IS THAT ALL THE FILMS ARE IN THE SAME COLOR PALETTE. FOR THE FIRST TIME, YOU CAN USE SEVERAL DIFFERENT TYPES OF COLOR FILM DURING THE WEDDING AND THEY'LL ALL STILL MATCH IN THE WEDDING ALBUM.

Only a second camera could capture this moment. Also, don't be afraid to photograph using a slower shutter speed. Here, dragging the shutter added movement and impact to the image.

HASSELBLAD 503CW, 30MM CF FISHEYE LENS, f5.6 AT 1/60, KODAK PORTRA 400VC

The Hasselblad 100mm lens, set at f5.6 at 1/60, is the ideal tool for shots down the aisle. Give your assistant the Quantum Q-flash and position him or her just behind the subject, at a 45-degree angle and on the same side of the aisle as you. The light will be turned toward the back of the room, helping to separate the subject from the background.

Hasselblad's PME90 prism is also useful for this stage of the wedding, allowing you to maximize your creativity quickly. You can spot meter at any time and get an incredibly accurate reading of any point within the image area.

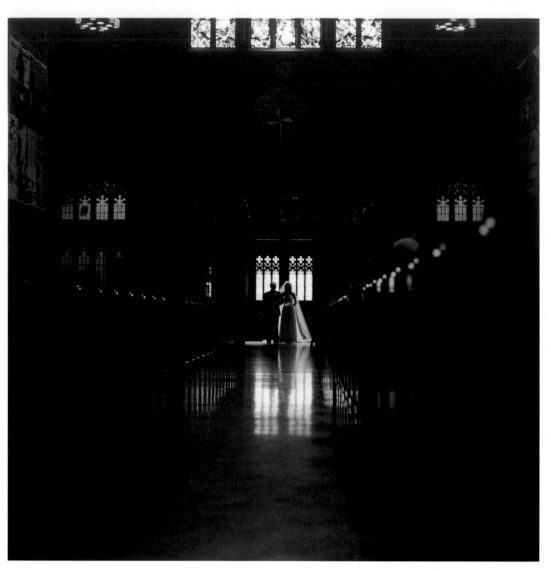

Another example of how a second camera comes into play, this one set up at the front of the church. The camera was used without a flash and metered off the light coming through the doorway to create this wonderful silhouette of the bride and her father about to come down the aisle.

HASSELBLAD 503CW, 100MM CF LENS, f5.6 AT 1/125, KODAK PORTRA 400VC

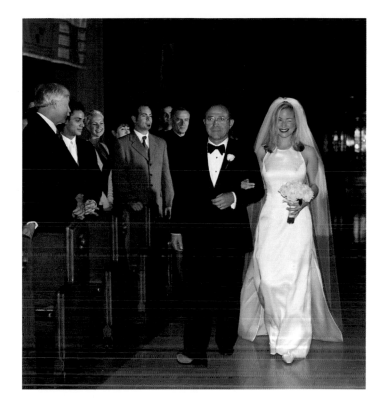

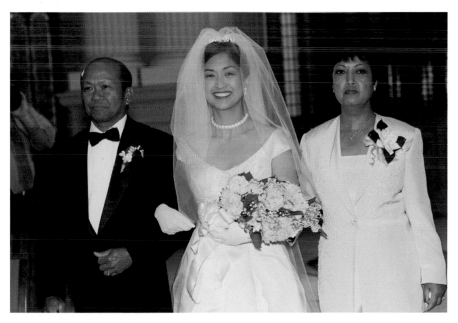

ABOVE, LEFT AND RIGHT: Don't worry about how much film you're using; just keep shooting and you'll capture some of the most wonderful moments. Seconds after the bride winked at her groom in the first image, the groom's father grabbed his son's arm and, without ever saying a word, conveyed, "She's so beautiful!"

HASSELBLAD 503CW, 100MM CF LENS, f5.6 AT 1/60, KODAK PORTRA 400VC

LEFT: Working with an assistant gives you the ability to capture moments in both color and black and white. This bride wanted the shot in black and white, while the parents wanted it in color.

HASSELBLAD 503CW, 100MM CF LENS, f5.6 AT 1/60, KODAK PORTRA 400VC

THIS MAY SOUND PRETTY BASIC, BUT TODAY'S **FASTER FILMS** ARE RESPONSIBLE FOR MANY OF BAMBI'S GREATEST IMAGES DURING THE CEREMONY. A NEW FAVORITE FOR COLOR IS KODAK PORTRA 800 FOR AVAILABLE LIGHT. FOR BLACK AND WHITE, TRY KODAK T-MAX P3200, RATED AT 1600. DEPENDING ON THE LENSES YOU'RE USING, KODAK PORTRA 400VC CAN ALSO BE TERRIFIC.

NOTE THAT YOUR ABILITY TO USE FASTER FILMS WILL DEPEND ON WHICH **LENSES** YOU'RE USING. YOU NEED THE ABILITY TO CAPTURE IMPORTANT SHOTS, NO MATTER WHERE YOU ARE, AND TO CREATE IMAGES WITH MAXIMUM IMPACT. IF YOU'RE USING A HASSELBLAD 503CW, WE RECOMMEND YOU HAVE AT LEAST THREE LENSES DURING THE CEREMONY: THE 30MM CF FISHEYE, THE 100MM CF, AND THE 180MM CF. THE 30MM FISHEYE WILL CAPTURE MAXIMUM WIDE-ANGLE SHOTS, WHILE THE 180MM IS PERFECT FOR TIGHTER FACE SHOTS OF THE MAJOR PLAYERS. THE 100MM IS RIGHT IN THE MIDDLE AND IDEAL FOR CAPTURING INTERACTION AMONG PEOPLE.

EXCHANGING VOWS

During the actual ceremony, the one rule every denomination has is that you can't use a flash. Think about it: Very few officiants ever said, "no photography," just "no flash." This is a perfect example of how photographers tend to create many of the rules and restrictions themselves! Why do so many photographers insist on standing in the "bleacher seats"? And why do they settle over and over again for only a few standard images of the ceremony?

For starters, let's move in on the scene. You don't need to be sitting in one of the families' sections; just find a location up close that's unobtrusive—maybe behind a column near the front of the altar.

And who ever told us that wedding photographers had to stand perfectly still? The audience is totally wrapped up in the wedding. As a result, you have the ability to move around and change positions to capture just the right image, often without even being noticed.

Finally, that second camera comes into play again during the ceremony. At the very last minute after the bride has walked down the aisle, move the second camera (and your assistant, if you have one) to a tripod at a preselected location in the back. This will allow you to get expansive shots of the ceremony from the rear. In the meantime, you discreetly move to your place in the front, where the action is.

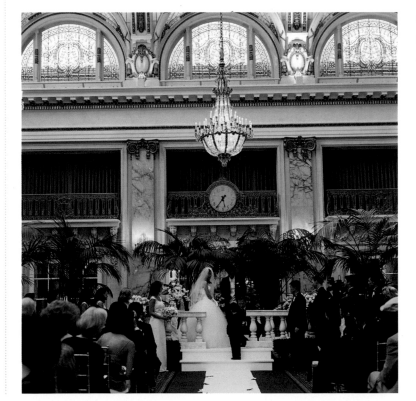

HASSELBLAD 503CW, 50MM CF LENS, f5.6 AT 1/30, KODAK PORTRA 400VC

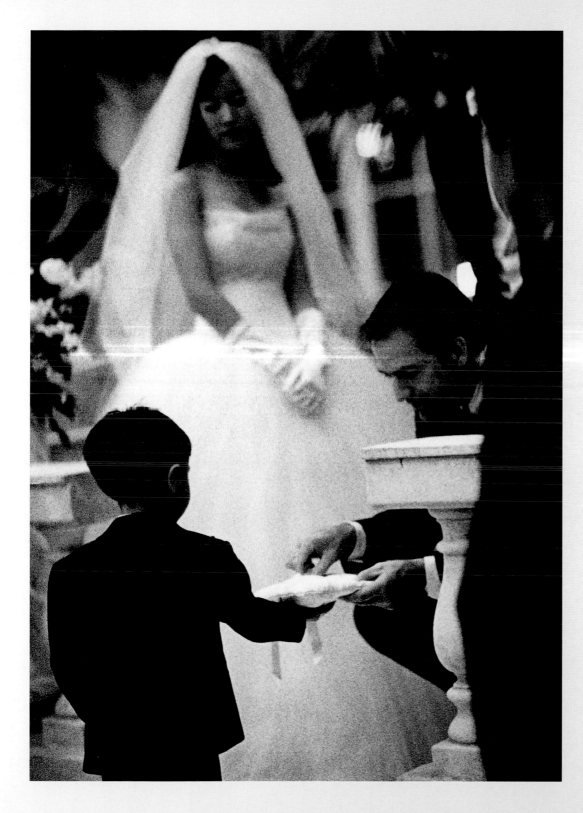

This second image, taken at almost the same time as the shot opposite, would have been missed with only one camera.
CANON EOS 1N, 85MM f1.2 LENS, f2.8 AT 1/125, KODAK T-MAX P3200 RATED AT 1600

Don't worry about how much film you're using. Your goal is to capture the excitement, romance, sensitivity, and passion of the ceremony.

CANON EOS 1N, 85MM f1.2 LENS, f1.2 AT 1/60, KODAK T-MAX P3200 RATED AT 1600

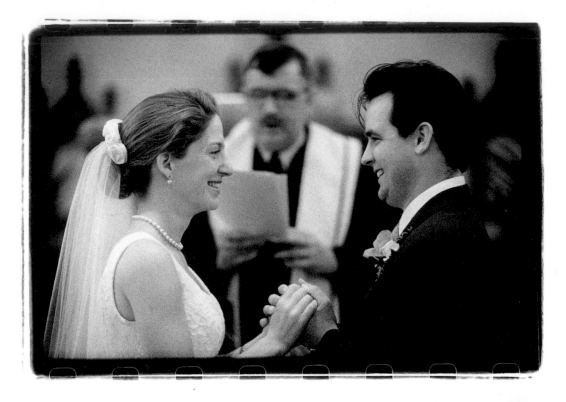

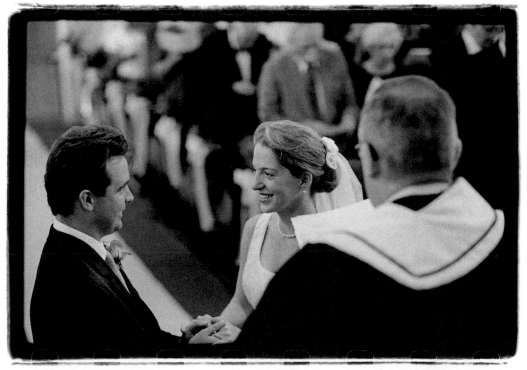

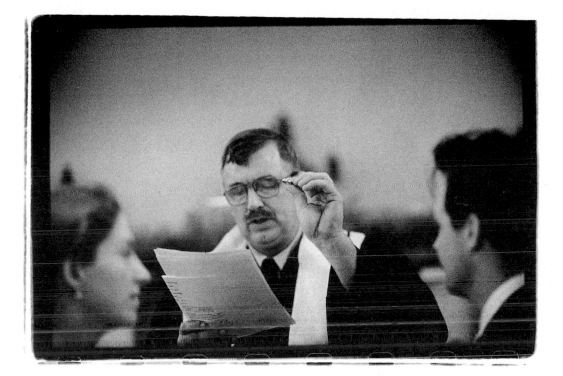

CANON EOS 1N, 85MM f1.2 LENS, f1.2 AT

1/60, KODAK T-MAX P3200 RATED AT 1600

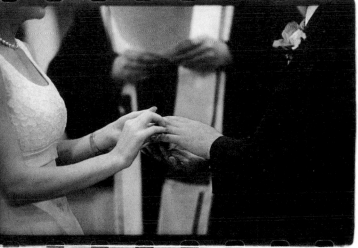

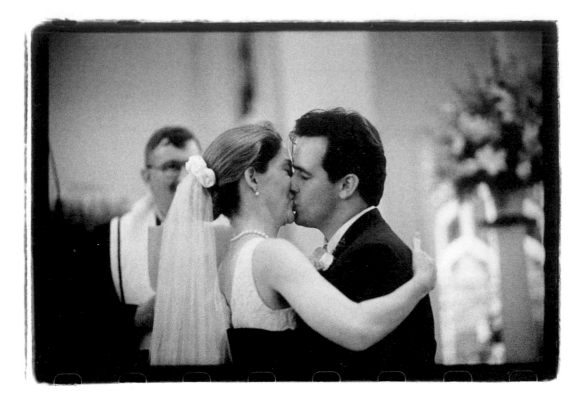

CANON EOS 1N, 85MM f1.2 LENS, f1.2 AT

1/60, KODAK T-MAX P3200 RATED AT 1600

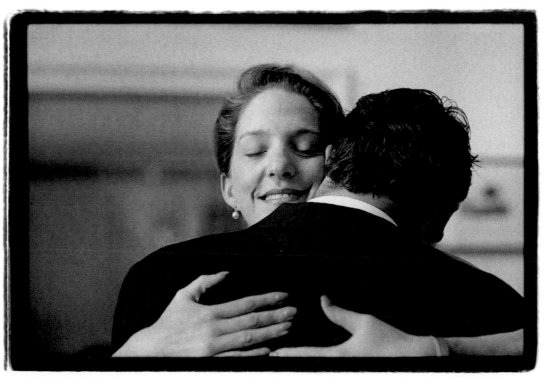

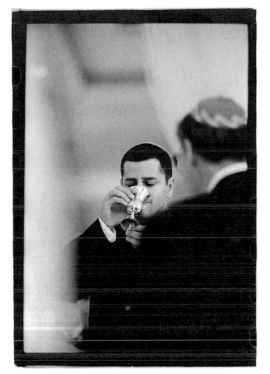

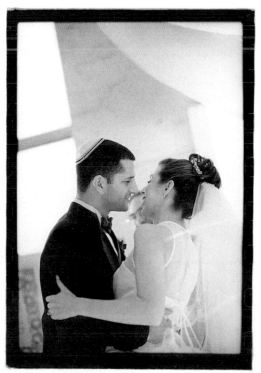

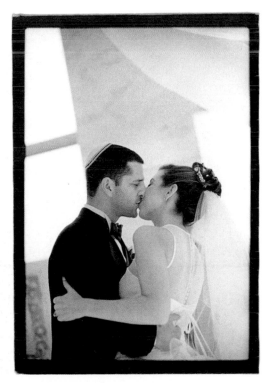

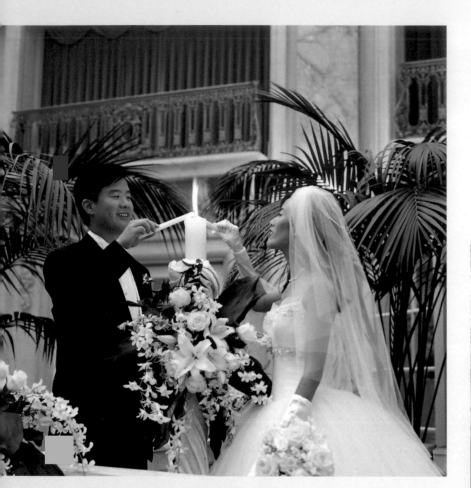

HASSELBLAD 503CW, 100MM CF LENS,
f4.0 AT 1/15, KODAK PORTRA 400VC

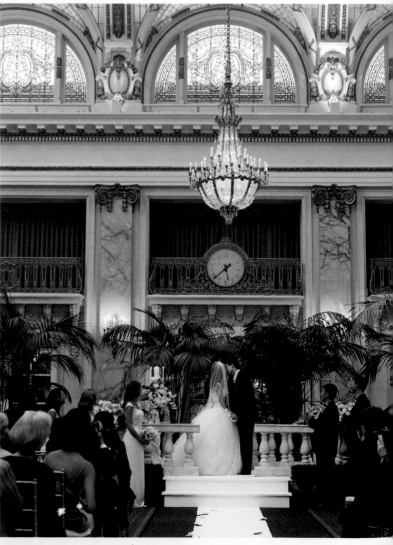

A second camera at the back of
the room allows you to capture
the overall elegance of the scene.
HASSELBLAD 503CW, 100MM CF LENS,
f5.6 AT 1/15, KODAK PORTRA 400VC

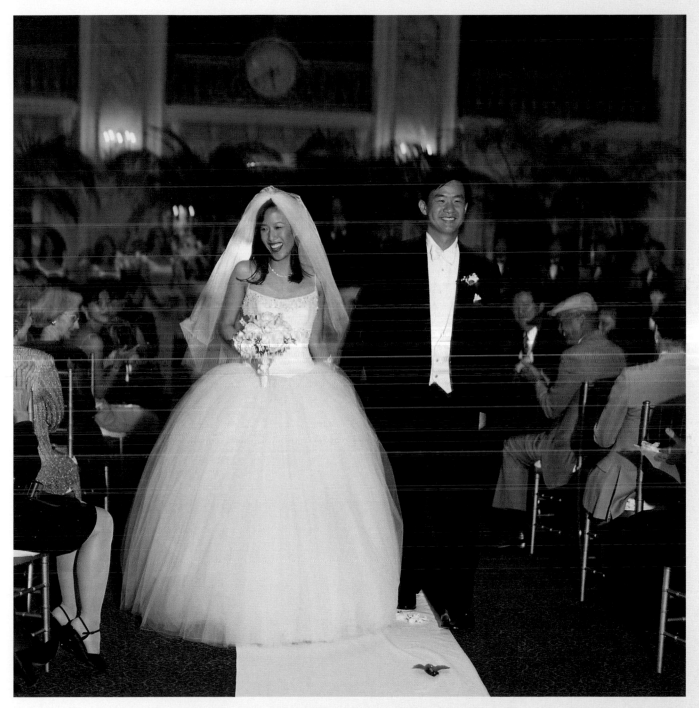

Separate your subjects from the background by having an assistant stand behind them, pointing a second flash toward the background.

HASSELBLAD 503CW, 100MM CF LENS, f5.6 AT 1/60, KODAK PORTRA 400VC, MAIN LIGHT PROVIDED BY ON-CAMERA QUANTUM Q-FLASH SET AT f5.6, FILL LIGHT PROVIDED BY

QUANTUM Q-FLASH SET AT f4.0 AND ANGLED TOWARD BACKGROUND

Remember to look for formal images at informal moments throughout the day. A tight shot of the groom's face just after the ceremony, taken with a narrow depth of field, can provide one of your strongest portraits without the constraints of formal posing.

CANON EOS 1N, 85MM f1.2 LENS, f2.0 AT 1/25, KODAK T-MAX 400

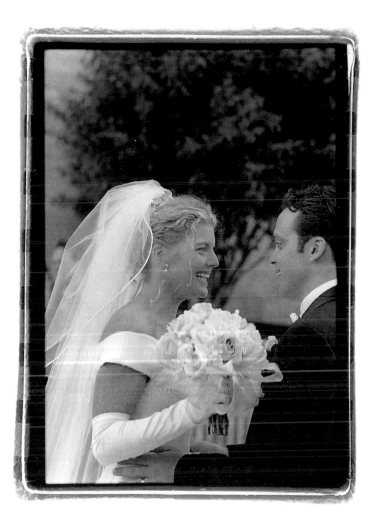

By following the couple immediately after the ceremony, you're able to capture that very first spark of pure joy. Don't limit yourself to just one image. Again, don't worry about how much film you're using!

CANON EOS 1N, 85MM f1.2 LENS, f5.6 AT 1/60, KODAK T-MAX 400

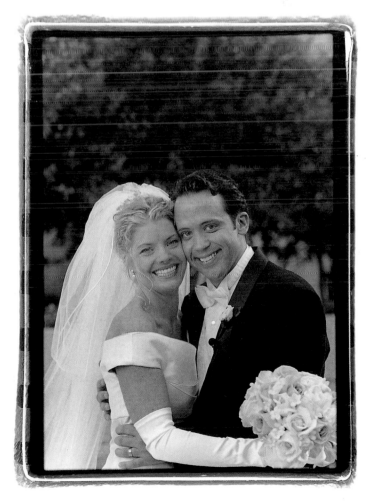

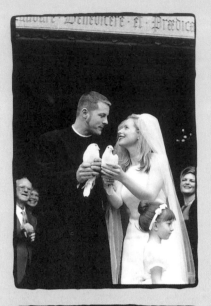

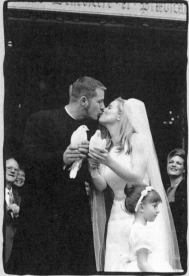

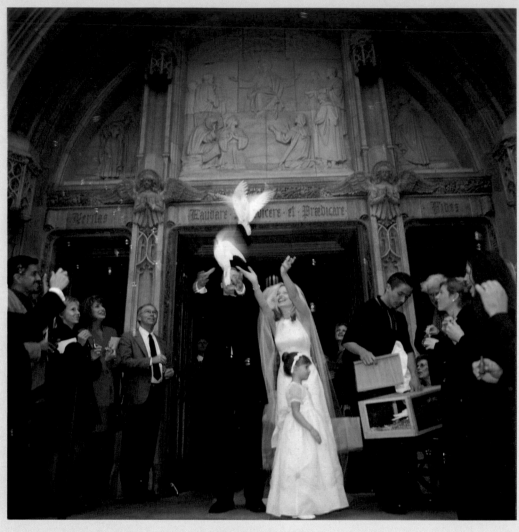

A slower shutter speed gave this image movement and impact.

HASSELBLAD 503CW, 50MM CF LENS, f5.6 AT 1/30, KODAK PORTRA 400VC

CANON EOS 1N, 85MM f1.2 LENS, f5.6 AT 1/60,

KODAK T-MAX 400

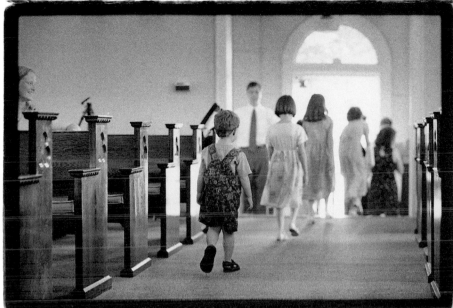

Pay attention to what's going on behind you. This shot of people walking out of the ceremony and into the sunlight tells an important part of the story.

CANON EOS 1N, 85MM f1.2 LENS, f0.5 AT 1/60, KODAK T-MAX P3200 RATED AT 1600

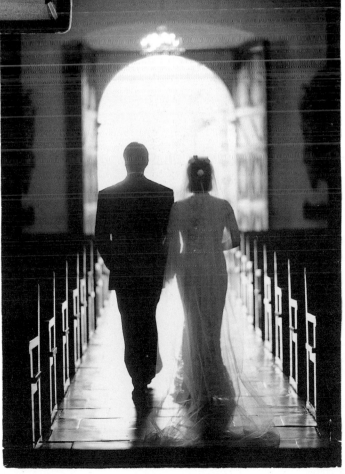

CANON EOS 1N, 85MM f1.2 LENS, f3.5 AT 1/60, KODAK T-MAX 400

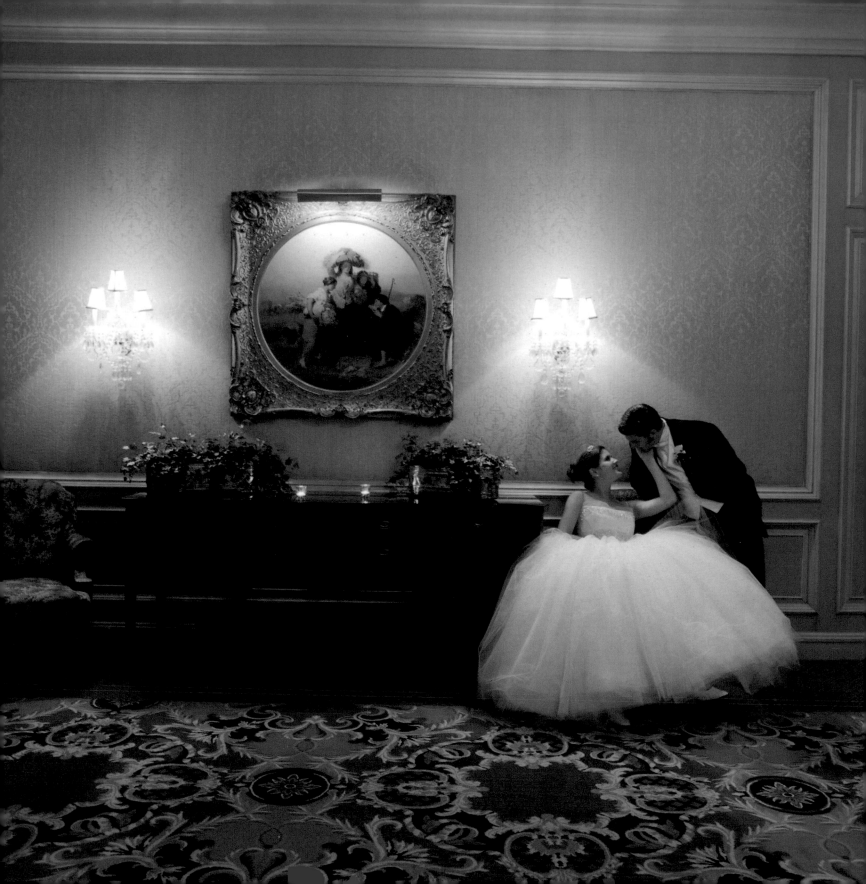

FORMALS

Most wedding photojournalists view having to do formals about as enthusiastically as they would a root canal. The fact remains, however, that most brides and grooms will want at least a few posed formals, and it's your job to give them what they want. Even if you plan to take only nontraditional images, you have to understand the rules of formal portraiture before you can break them, just as you have to understand exposure and depth of field to create the finest avant-garde images.

You have to understand the rules of formal portraiture befor you can break them.

For the purposes of this discussion, let's assume your clients are far more photojournalistic than traditional in their requirements. If you keep it simple, formals can be almost painless.

HASSELBLAD 503CW, 100MM CF LENS,
f5.6 AT 1/30, KODAK PMC400

WHEN TO TAKE FORMAL PORTRAITS

There's no one particular time that formal portraits must be taken. Think about breaking them up, doing some before and some after the ceremony. Try to minimize the time spent taking formals after the ceremony, when energy is high and no one wants to stand around.

One way to save time is by taking a few posed formals at the bride's home just after she's put on her gown. Plan to arrive at the bride's house with at least a half hour to spare and look for good locations to photograph the bride, her wedding party, and whoever else is available. Select the simplest and most versatile locations; you don't want the background to detract from the subject matter. If the house is too cluttered and doesn't present opportunities for great images, move out of the house. The front porch might give you just the simplicity you need.

The groom and his groomsmen will typically be photographed before the ceremony at the location of the wedding. Again, look for simple, unobtrusive locations that enable you to capture what's happening on the faces of your subjects. Try to avoid photographing in locations that are too formal, which will remind everyone of the event ahead.

Most clients choose to have the bulk of their formals taken after the ceremony. You should have already chosen a location that offers the most benefits with the least amount of work and an easy traffic flow. Your goal is to have all group images completed in twenty minutes or less. Work as efficiently as possible and clear the room quickly so your wedding party can get back to the reception and greeting guests.

The best way to work such sessions is to start with the bride, the groom, and the bride's family, including grandparents. Then ask all relatives to step out except the bride's parents. Next, ask the groom's parents to step in to include both sets of in-laws. Then dismiss the bride's parents and have the rest of the groom's family step into the photograph. Now move onto the bridal party. First, take the entire party. Then have the bridesmaids stay and the others step out. The bride can then be asked to step out and the bridesmaids dismissed while you shoot the groom with his groomsmen. The last few moments should be spent photographing just the bride and groom together.

DYNAMIC POSING

Even those wedding photojournalists most staunchly resistant to formal portraiture might as well create the best formal images possible. The little extra amount of work it takes to add a fashion flair to your formals will be completely offset by the amount of fun you'll have with the wedding party and the quality of the final photographs.

Remember those images we asked you to look at in *Vogue, Cosmopolitan,* and *Modern Bride*? What did they have in common? They all shared an electric, high-fashion feel; they were simple, yet emotionally powerful. You want to add those same elements to images of the couple, their family, and the wedding party.

THE BRIDE

Let's start by photographing the bride. It's best to work with simple poses; the idea is to add a sense of fashion to your images with minimal fuss. Stand in the direction you want the subject's shoulders to face and set her feet about a foot apart. Have her press her hips lightly back to accentuate the flattering "s" curve. You want to create body lines that flow rather than angle sharply. Just having the bride lower her flowers to her waist, for example, will get rid of the sharp right angles formed by the bend of her elbows. If you want to eliminate a double chin, change your camera angle to photograph the bride from a slightly higher plane. Have her pull her chest forward and lean slightly toward the camera, leading with her chin.

It's easy to get natural responses from the bride by simply talking with her and making her feel comfortable. Ask her a question or two—not about the wedding, but about frivolous things. Where did she get her shoes? How did she meet her maid of honor? What's the funniest thing that ever happened between her and any of her bridesmaids? Work to get her relaxed. Then capture the moment on film when she's telling you about herself instead of thinking about the event ahead.

When posing your subjects, remember one simple rule: If it's a joint, bend it! Whether working with men or women, just a subtle bend of arms and legs will eliminate stiffness and make them look more relaxed and natural.

TRY SWITCHING BACK AND FORTH BETWEEN DIFFERENT TYPES OF FILM TO ADD A LITTLE CREATIVITY TO YOUR FORMAL IMAGES. THIS IS ALSO THE PERFECT TIME TO BYPASS A FLASH AND SHOOT WITH AVAILABLE LIGHT. PHOTOGRAPH AS OFTEN AS POSSIBLE WITHOUT A FLASH; THE MORE EQUIPMENT YOU HAVE THE MORE APPREHENSIVE YOUR SUBJECTS WILL BE AND THE LESS NATURAL THEIR EXPRESSIONS.

Notice how this bride was posed in an "s" curve for a more flattering line.

HASSELBLAD 503CW, 180MM CF LENS, f5.6 AT 1/250, KODAK PORTRA 400VC, FILL LIGHT CREATED WITH REFLECTOR

HASSELBLAD 503CW, 100MM CF LENS, f5.6 AT 1/250, KODAK PMC400

ABOVE: Notice again the "s" curve formed by the bride's pose, and the way it contrasts with the architecture around her.

HASSELBLAD 503CW, 100MM CF LENS, f5.6 AT 1/125, KODAK CN

BELOW: If the bride is seated on the floor, relax: She's not going to be sitting on the gown, but on her slip. Just make sure the general area is relatively clean and that the gown itself stays off the floor.

HASSELBLAD 503CW, 50MM CF LENS, f5.6 AT 1/250, KODAK PORTRA 400NC

THE GROOM

Just as with the bride, the key to creating great posed images of the groom is to keep him relaxed. Start by having him stand at a 45-degree angle to the camera. Then have him lift the foot closest to the camera and move it slightly toward you, shifting his weight to his back leg. This will create a more natural appearance. Keep the conversation going and ask him some viewpoint questions to keep him relaxed and from feeling like he's "overposing."

HASSELBLAD 503CW, 100MM CF LENS, f5.6 AT 1/125, KODAK T-MAX 400

While portrait photographers have argued for years about whether or not a male subject should leave his thumb outside the pocket, leaving the thumb outside is unnatural looking. No guy puts his hand in his pocket and leaves out the thumb!

HASSELBLAD 503CW, 100MM CF LENS, f8.0 AT 1/250, KODAK PORTRA 400VC, AVAILABLE LIGHT WITH SILVER AND GOLD MESH REFLECTOR BOUNCING MORE LIGHT ONTO THE SUBJECT

When taking group formals indoors, use the **Quantum Q-Flash** as your main flash, set at F8.0 on a monopod held by an assistant and fired using a Quantum radio slave. For your on-camera fill flash, use the **Metz50** set at F5.6. Whether shooting formals indoors or out, set your shutter speed based on the ambient reading. To use fill flashes for a natural look outside, set the strobe one stop below your ambient light reading. For example, if the ambient light reading is F5.6, set the fill flash at F4.0. The Quantum Q-flash should be set on "manual."

THE WEDDING PARTY

When it comes to doing group photographs, the keys to success are flexibility, speed, simplicity, and a terrific sense of humor. Anxiety is high and the best images will only be created if you can get the subjects to relax and interact with each other.

Position your subjects in staggered positions and stay away from having them all line up on the same plane. Try pairing and grouping your subjects to add interest, as in the images shown opposite. The more dynamic the poses, the more fun they're going to have and the less important the background.

If the bride is a little heavyset, have a bridesmaid stand slightly in front of her and have her press her hips toward the back to create a more elegant line.

Pay attention to the styles of clothing worn by the wedding party. More contemporary attire is a cue that you can be more relaxed in the posing. Special clothing can also give you ideas. If, for example, the bride selected a particular bridesmaid's dress because of the cut of the back, you might try posing a couple of subjects at a 45-degree angle to the camera to start picking up details of the dress in the overall formal.

Never walk away from a posed shot too soon! The real magic seems to happen after the formal image has been taken and everyone relaxes.

HASSELBLAD 503CW, 180MM CF LENS, f4.0 AT 1/125, KODAK PORTRA 400VC

If your subjects are relaxed, it only takes a second to really bring out the fun of the wedding day.

HASSELBLAD 503CW, 50MM CF LENS, f5.6 AT 1/250, KODAK PORTRA 400VC, FILL LIGHT PROVIDED BY QUANTUM Q-FLASH SET AT f4.0 AND PLACED AT A RIGHT ANGLE TO THE CAMERA

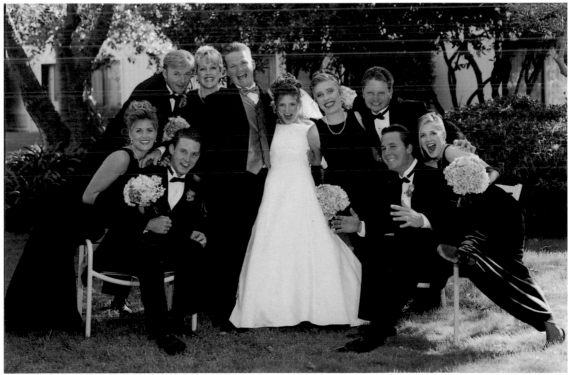

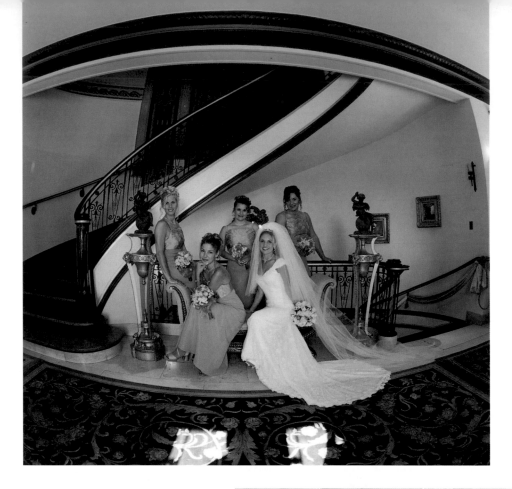

A fisheye lens helps to highlight some architectural lines of this hotel that might have otherwise been missed. A contemporary pose further adds to the image's impact.

HASSELBLAD 503CW, 30MM CF FISHEYE LENS, f5.6 AT 1/125, KODAK PORTRA 400VC

If you work quickly, your subjects will stay relaxed with natural smiles, simply enjoying the wedding day.

HASSELBLAD 503CW, 50MM CF LENS, f5.6 AT 1/15, KODAK PORTRA 400VC, MAIN LIGHT PROVIDED BY QUANTUM Q-FLASH SET AT f8.0 AND MOUNTED ON A MONOPOD, FILL LIGHT PROVIDED BY ON-CAMERA METZ50 SET AT f5.6

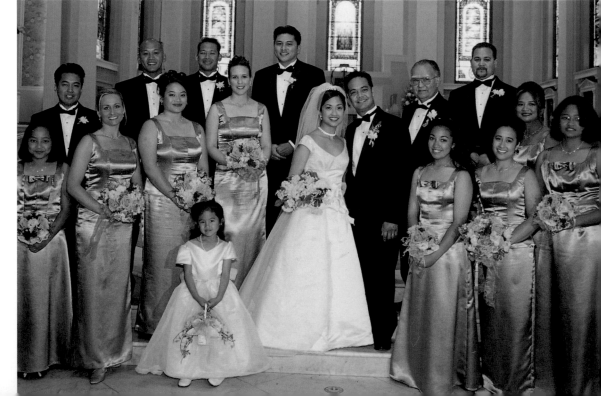

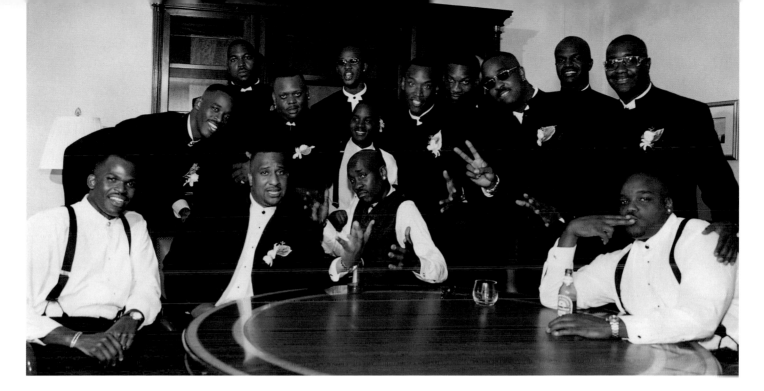

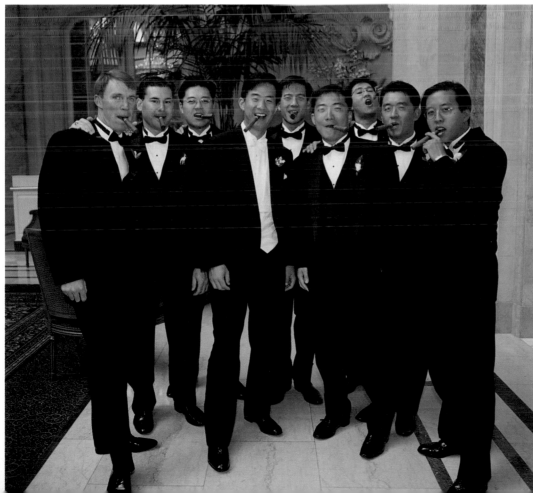

ABOVE: Always take into account the subjects' personalities when taking formal images. Expressions and body language mean volumes more than compositional perfection.

HASSELBLAD 503CW, 50MM CF LENS, f5.6 AT 1/30, KODAK PMC400, MAIN LIGHT PROVIDED BY VISATEC 1600 MONOLIGHT SET AT f5.6 WITH UMBRELLA, FILL LIGHT PROVIDED BY ON-CAMERA QUANTUM Q-FLASH SET AT f4.0

LEFT: HASSELBLAD 503CW, 50MM CF LENS, f5.6 AT 1/15, KODAK PORTRA 400VC

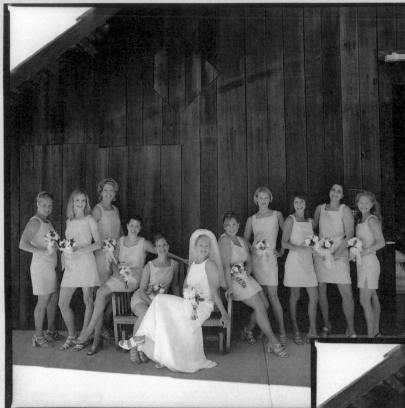

Don't be afraid to use chairs to bring people closer together— just stay away from firing squad lineups. Remember, when the posing is dynamic it doesn't matter what the background is. In this case, an old barn becomes the ideal backdrop. And guess what? Both images went into the bride's album.

HASSELBLAD 503CW, 50MM CF LENS, f5.6 AT 1/500, KODAK T-MAX 400

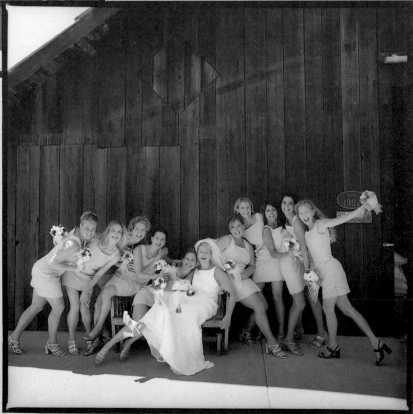

THE BRIDE AND GROOM

While a few posed images of the bride and groom can be taken after the group formals, try finding a few moments during the reception when you can sneak the couple away for some more relaxed, intimate shots. By this point in the day they will be more at ease than during the larger group session, and energy should be high. Working quickly, start with some traditional poses, then use your creativity for images with a more candid look.

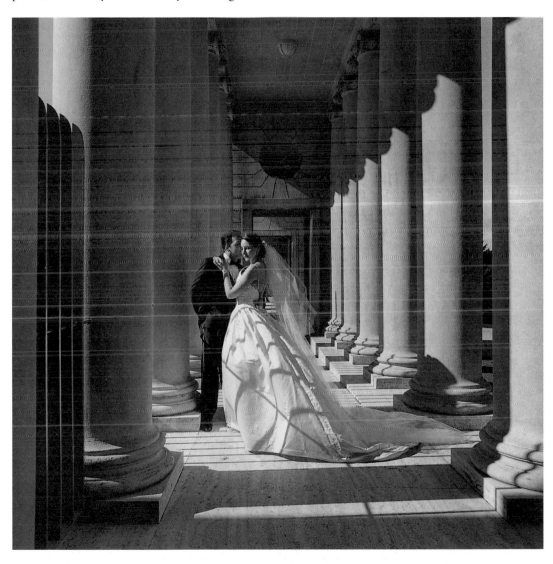

Take advantage of strong architectural lines or interesting light patterns to add impact and drama.

HASSELBLAD 503CW, 100MM CF LENS, f8.0 AT 1/125, KODAK T-MAX 400

TILTING THE CAMERA

Camera tilt adds a sense of motion to an image. As with all special techniques, be careful not to do too many images this way. You only need one or two for impact in the finished album.

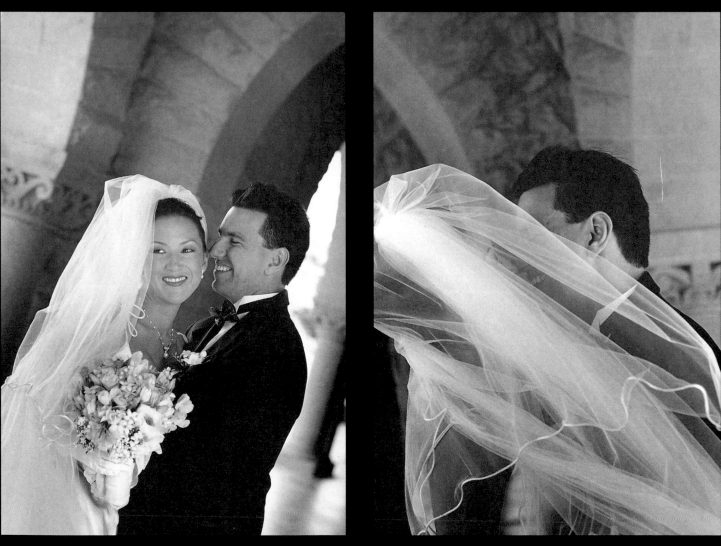

Notice the camera tilt used in the first image, a technique that adds motion and impact.

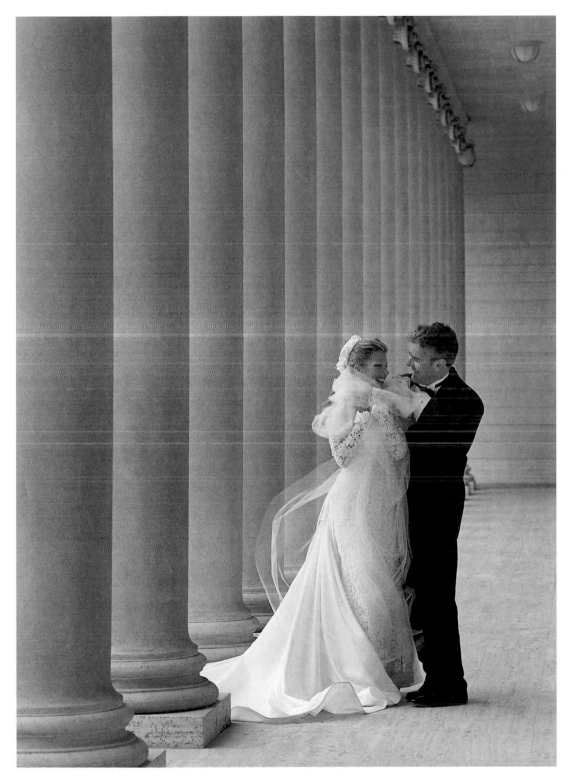

Don't get hung up on posing. Your number one goal is to simply capture the magic in the bride's and groom's faces.

HASSELBLAD 503CW, 100MM CF LENS, f5.6 AT 1/250, KODAK T-MAX 400

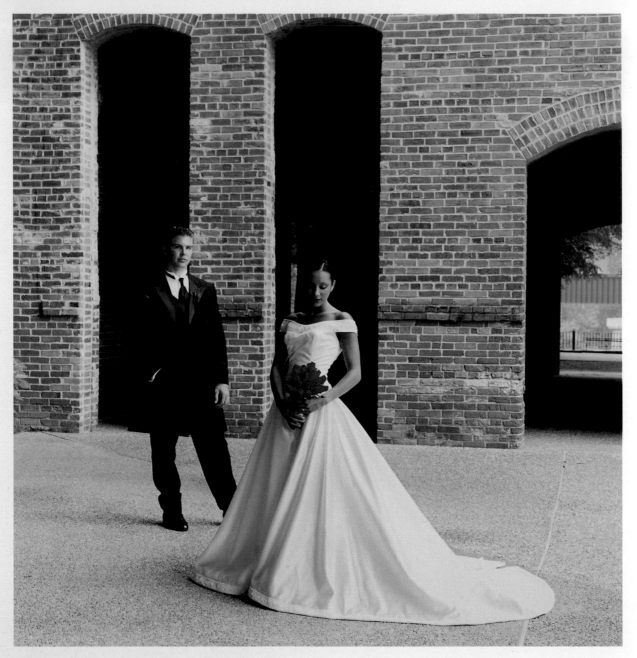

The strong lines and lighting of the bricks combine to create dramatic, high-impact backgrounds for these otherwise average images.

ABOVE: HASSELBLAD 503CW, 50MM CF LENS, f5.6 AT 1/125, KODAK PORTRA 400VC

OPPOSITE: HASSELBLAD 503CW, 180MM CF LENS, f4.0 AT 1/125, KODAK PORTRA 400VC

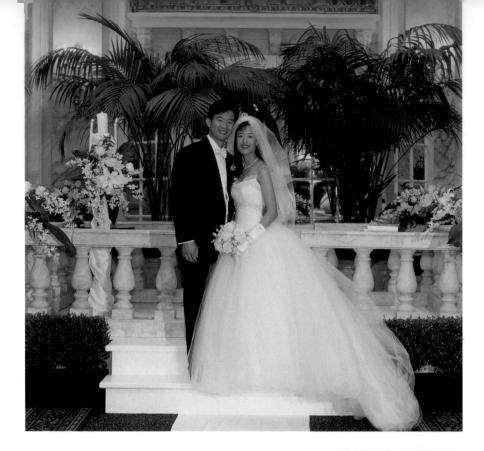

Creativity is important, but remember to capture a few of the more basic, traditional portraits typically desired by Mom and Dad.

HASSELBLAD 503CW, 100MM CF LENS, f5.6 AT 1/15, KODAK PORTRA 400VC

Camera tilt, architectural lines, and spontaneity in the pose all add to this image's impact.

HASSELBLAD 503CW, 100MM CF LENS, f5.6 AT 1/250, KODAK PORTRA 400VC

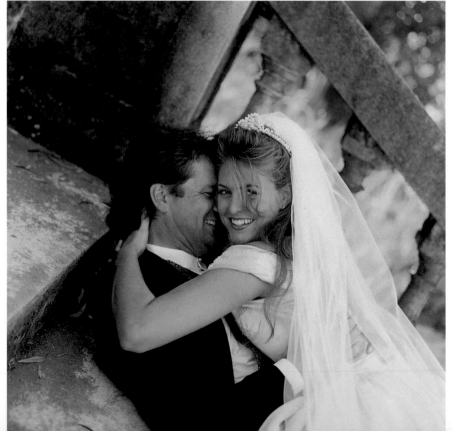

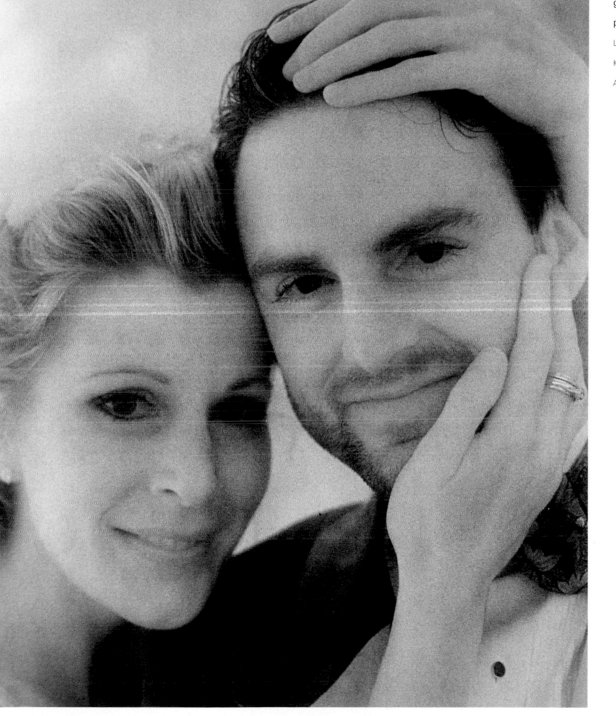

Interpreting a moment like this with infrared film is almost guaranteed to create a "wow" print.

LEICA R4, 50MM 2.0 LENS, f4.0 AT 1/60, KODAK HIGH-SPEED INFRARED RATED AT 125

CROSS-PROCESSING

For your less traditional clients, cross-processing is a technique sure to produce high-impact images. As in the image below, cross-processing creates an almost commercial look, with saturated colors that bleed together.

Start by using any slide film (Bambi uses Kodak Ektachrome 100VS). Kodak recommends overexposing the film by two f-stops, but Bambi rates it right at 100. Take the film out and give the lab very clear instructions to process the film in C-41 chemistry, as if it were print film. If the image is a face shot, ask the lab to dial out as much green as possible, to print from skin, and then to just let the colors go wild. Your slide film will come back as negatives, and will become very illustrative photographs. Like any of the more artistic techniques discussed here, cross-processing should be used only in small doses.

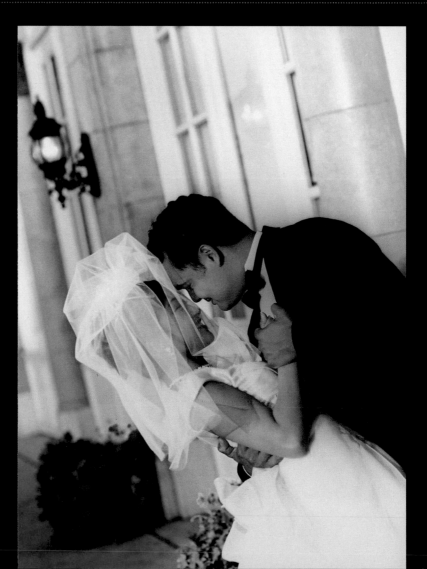

The combination of cross-processing with a little camera tilt turns this into a standout print.

CANON EOS 1N, 85MM f1.2 LENS, f5.6 AT

1/125, KODAK EKTACHROME 100VS

USING CARS AS PROPS

Many couples will spend an inordinate amount of money on transportation to and from their wedding. Antique cars, stretch limos, and Rolls Royces all top the lineup. The car can be important to the bride and groom and, even better, it has the potential to be an incredible prop in even the most challenging locations. There's virtually no part of the vehicle that won't help to create a terrific image, so let your creative juices flow!

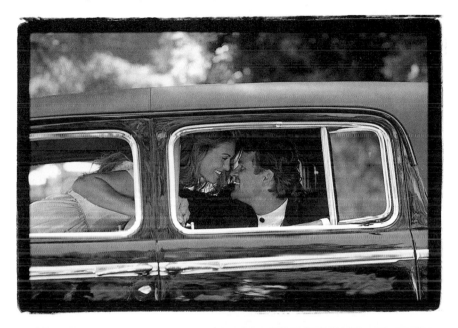

For these images, a reflector was used to direct more light into the faces of the subjects. CANON EOS 1N, 85MM f1.2 LENS, f8.0 AT 1/250, KODAK T-MAX 400

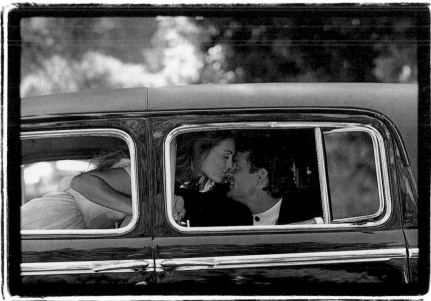

CANON EOS 1N, 85MM f1.2 LENS, f5.6 AT

1/125, KODAK T-MAX 400

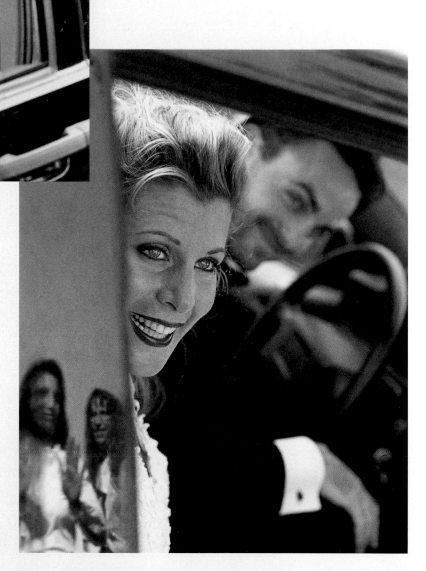

Pay attention to reflective sur-
faces. It was a bonus to get fam-
ily members waving goodbye.

CANON EOS 1N, 85MM f1.2 LENS, f4.0 AT

1/125, KODAK T-MAX 400

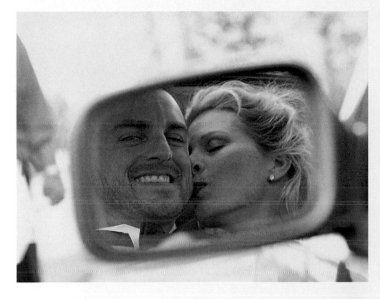

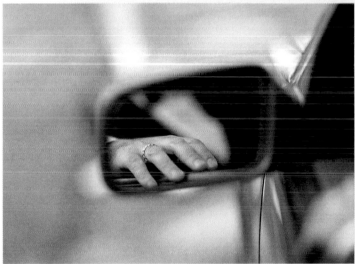

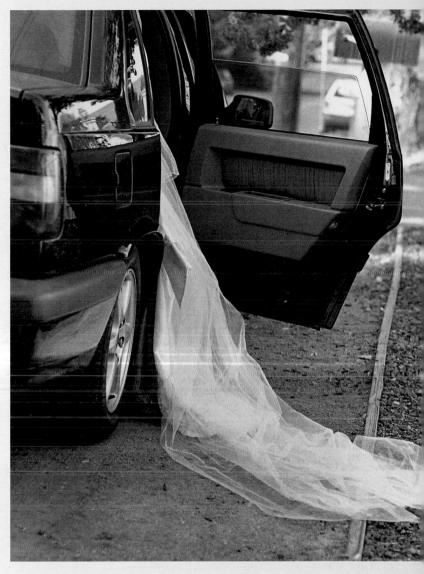

Reflective surfaces can also help you focus in on your subject(s) to capture more illustrative moments.

ABOVE TOP: CANON EOS 1N, 35–105MM ZOOM LENS, f3.5 AT 1/60, KODAK T-MAX 400

ABOVE BOTTOM: CANON EOS 1N, 85MM f1.2 LENS, f3.5 AT 1/60, KODAK T-MAX 400

ABOVE: CANON EOS 1N, 85MM f1.2 LENS, f5.6 AT 1/125, KODAK T-MAX 400

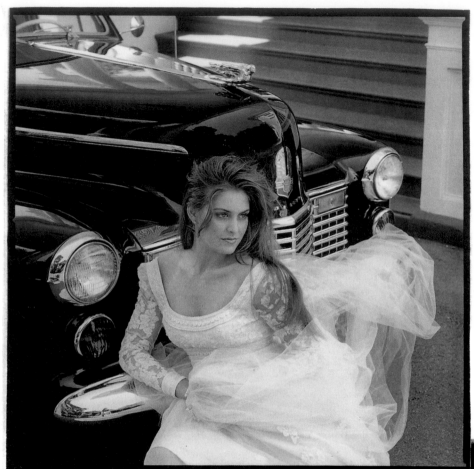

Here again, a reflector was used to direct more light into the bride's face.

HASSELBLAD 503CW, 100MM CF LENS, f8.0 AT 1/250, KODAK T-MAX 400

Don't hesitate to jump into the car to catch a shot looking out at the couple.

CANON EOS 1N, 35–105MM ZOOM LENS, f5.6 AT 1/125, KODAK T-MAX 400

LOCATION CHALLENGES

Let's talk a little about the challenge of working in less-than-spectacular locations—maybe the VFW hall or an old church in a tough part of town. It happens all the time. As the photographer, your challenge is to be a magician.

The trick in these cases is to control the environment with your choice of films. Black-and-white film, like the wallpaper in your first apartment, hides a multitude of sins. Unlike color film, in which various light sources have different effects, black-and-white film reads all light sources simply as "light," whether a table lamp, spotlight, window light, or videographer's light. Once you learn to see the light, black and white film becomes one of your strongest allies.

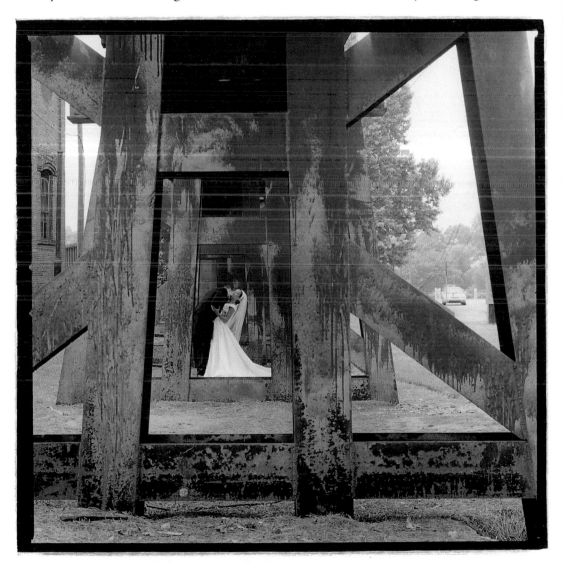

KODAK T-MAX FILM ISN'T YOUR ONLY ALLY IN DIFFICULT LOCATIONS. YOU SHOULD ALWAYS HAVE AT LEAST THREE **LENSES** WITH YOU, INCLUDING A WIDE ANGLE AND A PORTRAIT LENS. HAVING A VARIETY OF LENSES TO USE WILL ALLOW YOU TO HANDLE ANY LOCATION AND WILL STRENGTHEN THE ARSENAL OF CREATIVITY YOU HAVE TO OFFER YOUR CLIENT.

Look around you for strong architectural lines. In this case, a railroad bridge added a powerful design element.

HASSELBLAD 503CW, 50MM CF LENS, f8.0 AT 1/125, KODAK T-MAX 400

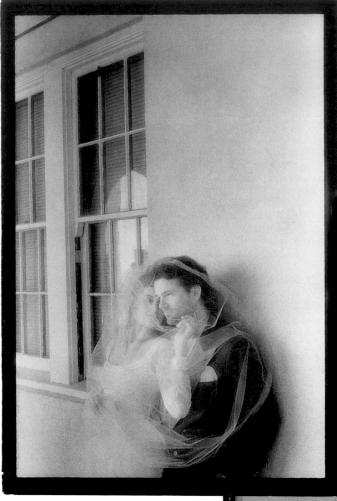

You can create drama against an ordinary stucco wall just by making the right choice in film.

LEICA R4, 50MM f2.0 LENS, f2.0 AT 1/60, KODAK HIGH-SPEED INFRARED RATED AT 200

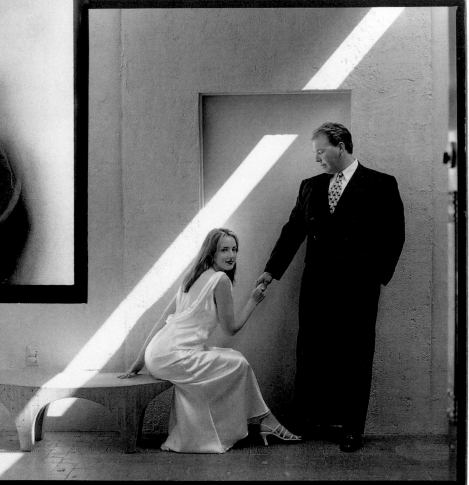

Under normal circumstances this would have been a challenging location, but notice the impact of the beam of light when combined with black-and-white film and a contemporary pose.

HASSELBLAD 503CW, 100MM CF LENS, f8.0 AT 1/250, KODAK T-MAX 400

When using slower shutter speeds, lock up the mirror to avoid camera shake and use a cable release with the camera tripod mounted.

KODAK CN FILM IS A C-41-PRO-CESSED BLACK-AND-WHITE FILM THAT CAN BE DEVELOPED AT THE SAME LAB WHERE YOU SEND YOUR COLOR FILM. WHILE IT'S NOT AS FORGIVING AS THE T-MAX FILMS, IT DOES ALLOW YOU TO USE ONLY ONE LAB AND IS GENERALLY LESS EXPENSIVE AND FASTER TO PROCESS.

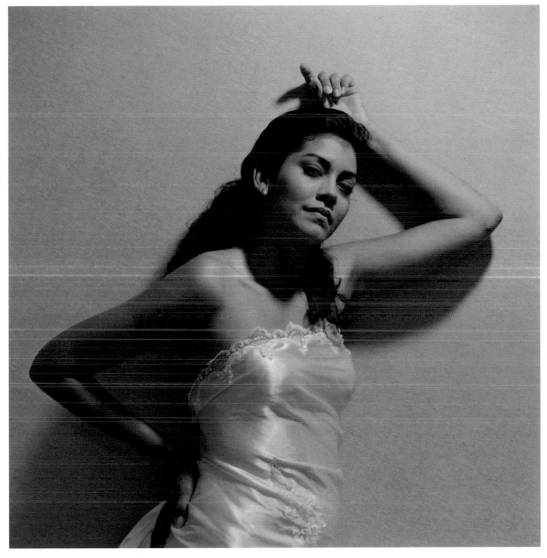

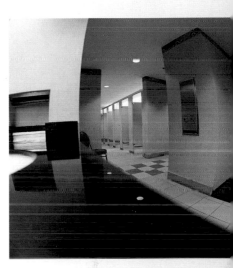

With the right film and lens you can do a bridal portrait in a public restroom! Here's the restroom at the Hyatt Hotel in Atlanta.

Notice how with black-and-white film, the ceiling spotter paints the wall and the subject's face with light. (The image was shot with black-and-white film, but was printed on color paper, giving it a sepia-toned effect.) Moving in and tightening the shot with a long lens resulted in a dramatic portrait.

HASSELBLAD 503CW, 100MM CF LENS, f4.0 AT 1/4, KODAK CN

The combination of black-and-white film and a narrow depth of field turns a simple stucco wall outside our bride's home into a perfectly neutral backdrop.

HASSELBLAD 503CW, 180MM CF LENS, f4.0 AT 1/125, KODAK T-MAX 400

Even when working with color film, a narrow of depth of field combined with a neutral background still creates high impact.

HASSELBLAD 503CW, 180MM CF LENS, f4.0 AT 1/125, KODAK PORTRA 400VC

Don't worry about the flowers if they don't arrive on time. Too many photographers are obsessed with waiting until the flowers arrive to photograph the formals. There's no question that the flowers are important, but often they'll hide some detail on the dresses. Instead, try having your subjects simply put one hand on their hip, stand with their feet a bit farther apart, and/or turn their bodies slightly into the camera, as shown opposite.

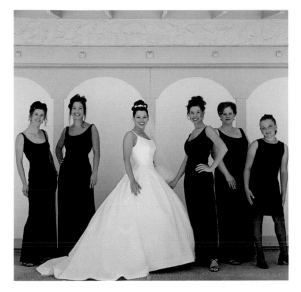

FAR LEFT: Ever thought about taking a formal photograph against a garage door? Notice the door's painful color, not to mention the fact that it's a garage.

LEFT: There's nothing too exciting about this image when shot with color film.

HASSELBLAD 503CW, 50MM CF LENS, f8.0 AT 1/60, KODAK PORTRA 400VC

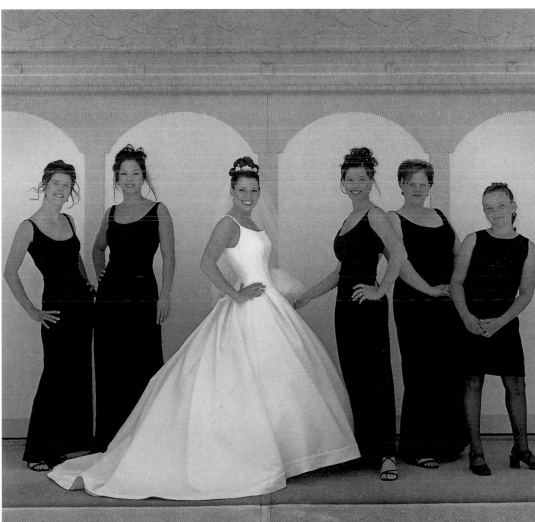

Now look what happens with black and white. Notice the strong compositional lines of the doors. Photographing in black and white and creating a dynamic pose completely neutralized the background.

HASSELBLAD 503CW, 50MM CF LENS, f8.0 AT 1/250, KODAK T-MAX 400

Cropping in the Camera

Whether or not you're faced with a challenging background, try creating high-impact images by focusing in on just one aspect of your subject(s). Use a long lens and your own creativity within the frame of the picture area to zoom in or highlight without having to crop in the darkroom.

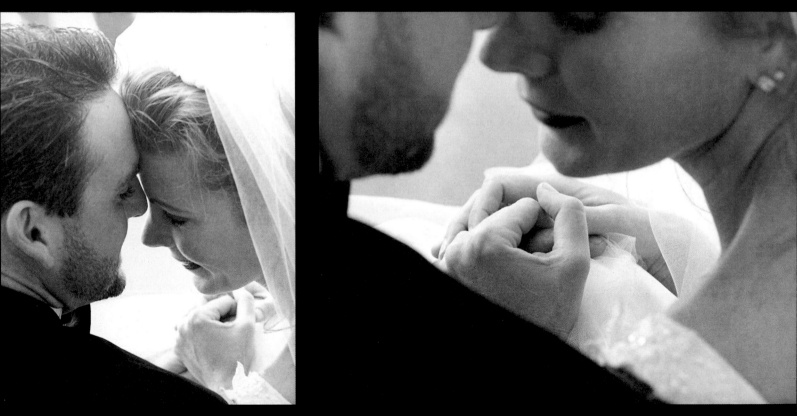

Notice how much more impact the second image gains by focusing entirely on the subjects' hands.

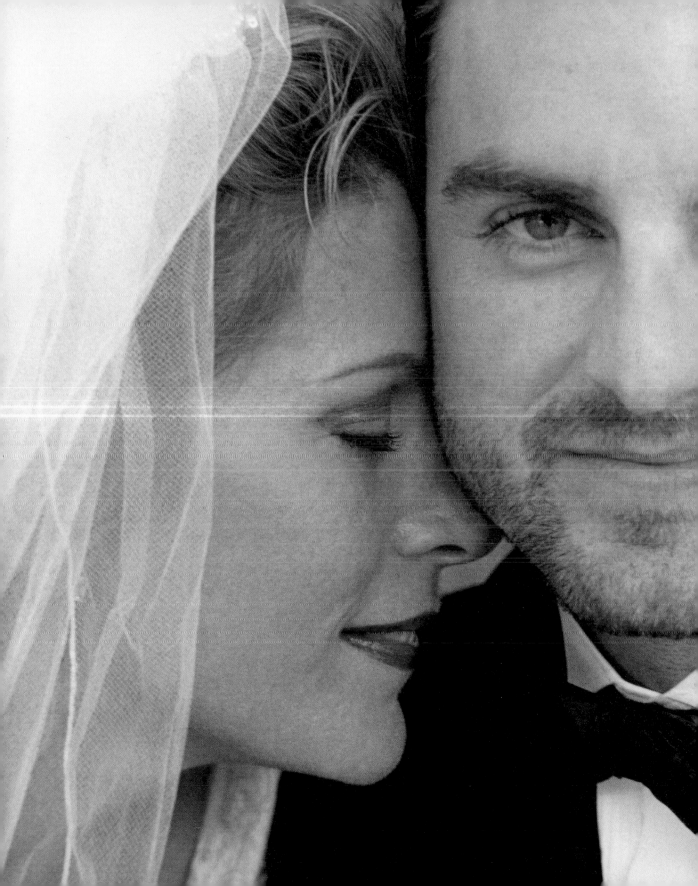

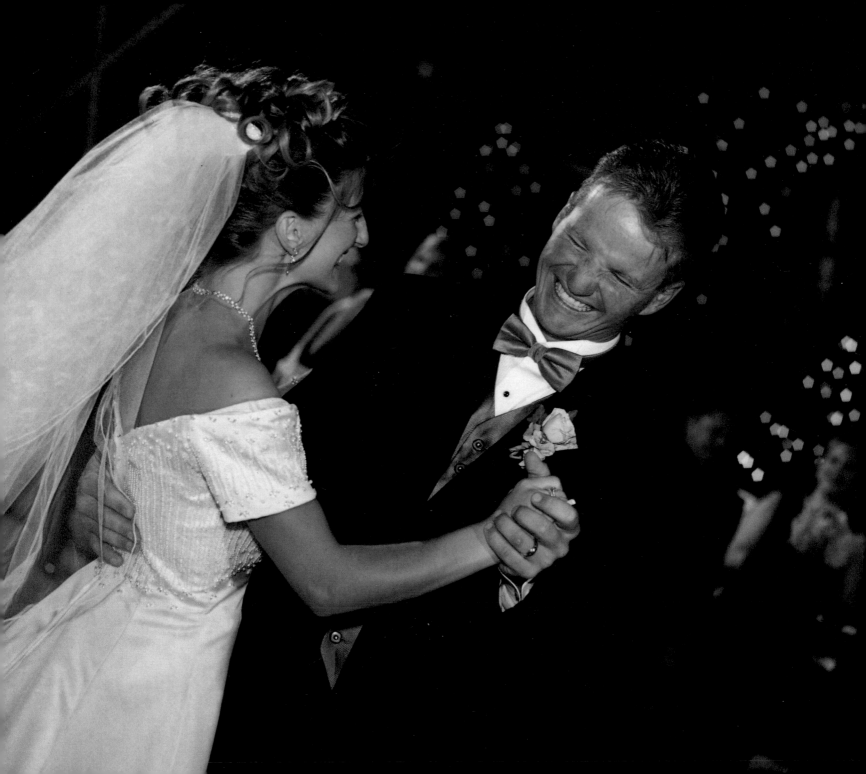

THE RECEPTION

In album after album, every reception seems to get the same coverage. Too many photographers use a checklist of poses: the first dance, the toast, the cutting of the cake, the bouquet toss, and a few more standards. These shots are essential, it's true, but every reception has the potential to be so much more!

Capture the details, the small but important moments.

The reception isn't just an event, but a celebration of family. It deserves far more than a few standard images. You have to capture the feeling of the moment, of families coming together. The bride and groom will remember so little from the reception. It's the photographer's job to thoroughly document the event.

Remember, you're a storyteller, and much of the reception's story lies in the details, the small but important moments between the new couple and their guests. Look beyond the faces of the bride and groom to capture the nuances that make each wedding unique.

RIGHT: Notice how much impact this image has, even though the bride's face isn't visible.

CANON EOS 1N, 85MM f1.2 LENS, f2.0 AT 1/60, KODAK T-MAX 400

BELOW: Emotion in an image will always outweigh vanity. Don't worry if you're not capturing the perfect portrait of the bride.

CANON EOS 1N, 85MM f1.2 LENS, f4.0 AT 1/250, KODAK T-MAX 400

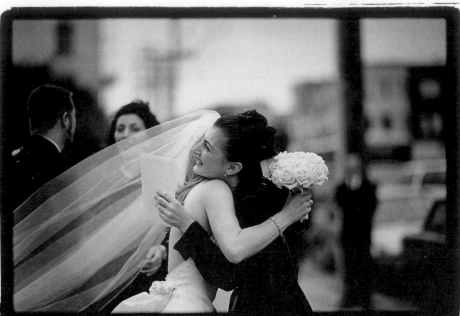

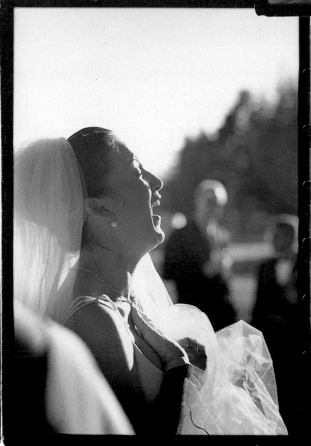

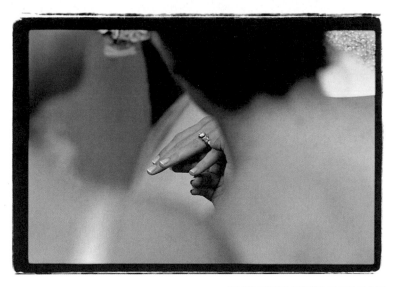

CANON EOS 1N, 85MM f1.2 LENS, f2.0 AT 1/60, KODAK T-MAX 400

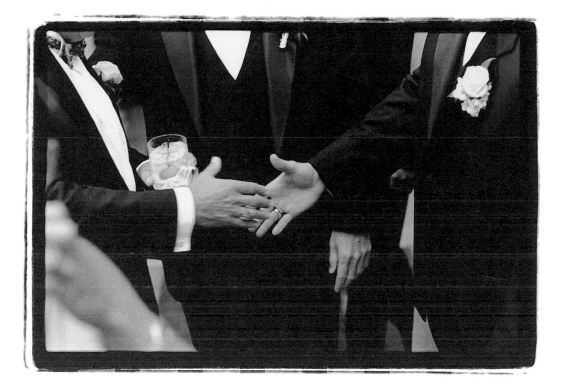

There's a lot of the story to be told between the end of the ceremony and the start of the reception—even something as simple as a handshake between the groom and his best man.

CANON EOS 1N, 85MM f1.2 LENS, f2.0 AT 1/60, KODAK T-MAX 400

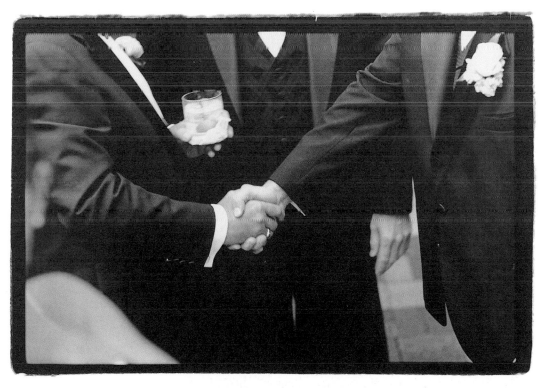

CAPTURING THE SETTING

While the bride and groom are enjoying the cocktail hour, make sure you document the reception site before anyone enters the room. Months have been spent planning the reception. Table settings, centerpieces, and the room itself have all been painstakingly chosen to create a very special atmosphere.

Images of the setting are not only important to the bride and groom, but are also a terrific way to network. Imagine the impact you could have by presenting a caterer or florist with images of the work they did for a wedding you photographed. He or she would have a new sales tool to use on potential customers, and you'd gain an important ambassador for your business!

This still life captures the invitation as well as details of the cake and a bouquet.
CANON EOS 1N, 85MM f1.2 LENS, f5.6 AT 1/16, KODAK PORTRA 400VC

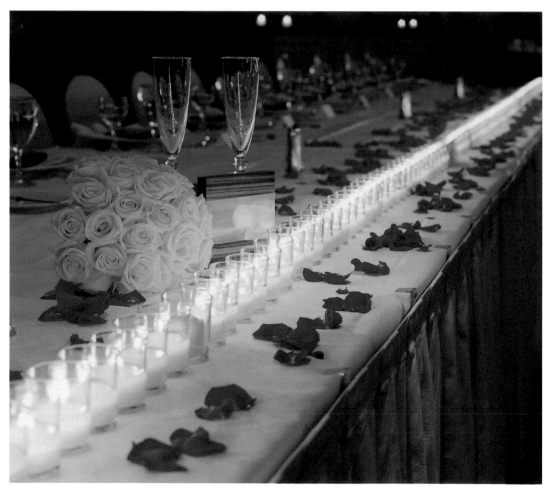

HASSELBLAD 503CW, 100MM CF LENS, f4.0 AT 1/2, KODAK PORTRA 400VC

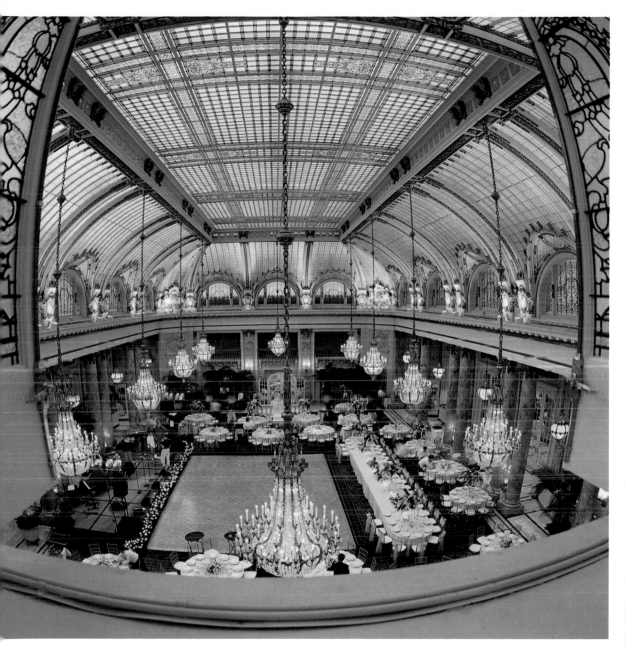

A **FISHEYE LENS** CAN BE USED TO CREATE A SPECIAL EFFECT WHEN YOU'RE WORKING TO CAPTURE AN ENTIRE SCENE. LIKE MANY OF THE SPECIAL TECHNIQUES WE'RE GOING TO BE TALKING ABOUT, IT'S IMPORTANT TO USE THE FISHEYE LENS SELECTIVELY SO THE IMAGES RETAIN THEIR IMPACT.

Do the best you can to get a good vantage point on the reception site. In this case, a fisheye lens is used to capture the scene.

HASSELBLAD 503CW, 30MM CF FISHEYE LENS, f4.0 AT 1/2, KODAK PORTRA 400VC

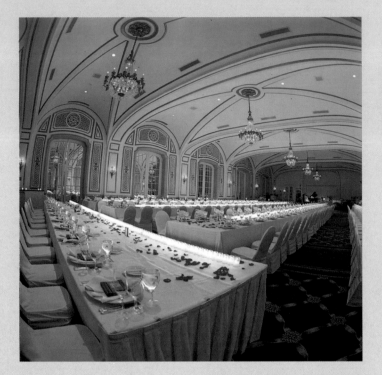

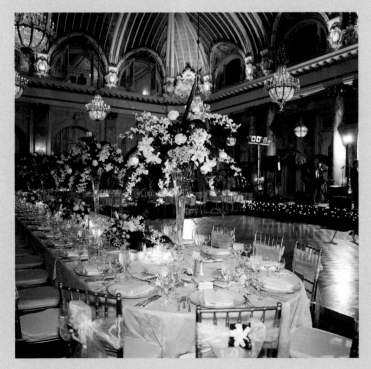

ABOVE, LEFT AND RIGHT: HASSELBLAD 503CW, 30MM CF FISHEYE LENS, f4.0 AT 1/4, KODAK PORTRA 400VC

LEFT: HASSELBLAD 503CW, 50MM CF LENS, f4.0 AT 1/4, KODAK PORTRA 400VC

OPPOSITE: HASSELBLAD 503CW, 100MM CF LENS, f4.0 AT 1/2, KODAK PORTRA 400VC

When taking table shots, use a **50mm lens** on the Hasselblad 503CW, set between eight and fifteen feet to prefocus your lens. Practice prefocusing. It saves time and gives you the freedom you need to constantly search for decisive moments.

TABLE SHOTS

Let's talk for a moment about capturing table shots. The purpose of table shots is to document who's at the wedding, and whether you're a portraitist or a photojournalist, most traditional table shots will look pretty much the same. The difference, however, is in how and when you take them. If you're shooting table shots while people are still eating, just to get them out of the way, then you're not giving it your best effort.

Let's get the job done during the very short window just before the reception goes into full swing. No food has been served yet and the table is relatively clean. If you need to move the centerpiece, this is just about the only time you can do it. It's also the only time when people aren't really doing anything.

Efficiency is key. Simply approach each table and explain that the bride and groom have made a special request that everyone attending be photographed. Point to four people and ask them to stand behind people already seated. If you're working with an assistant, you can be creating the image at one table while your assistant is getting the next group ready.

When shooting a traditional Asian wedding, it's an absolute necessity to take table shots of all the guests. Every image will be put into the album and placed according to a specific hierarchy.

The general rule is to stay away from creating images while people are eating. However, the right lens and exposure can add high impact to a table shot.

HASSELBLAD 503CW, 100MM CF LENS, f4.0 AT 1/2, KODAK PORTRA 400VC

THE TOAST

There are a dozen possible images of toasts given at the reception, not just the standard shot of the best man. As always, look for detail to round out the story. The key is to capture the human experience at that very moment. It's not about the glasses being raised, but about the sense of family in the room.

WHEN SHOOTING IN A DIMLY LIT ROOM, SUCH AS DURING THE TOAST, METER IN THE MIDTONES OF THE FACE. THIS IS THE PERFECT TIME TO PLAY OFF THE VIDEOGRAPHER'S LIGHTING.

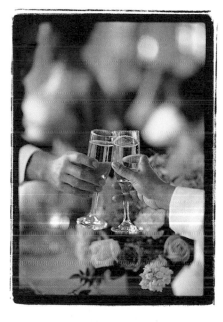

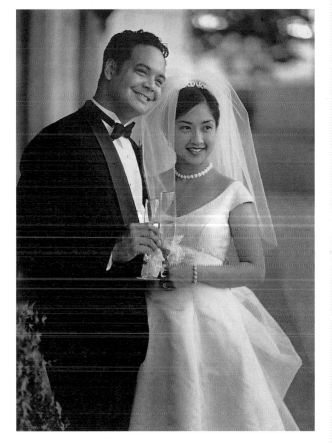

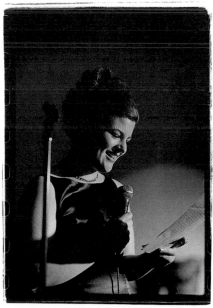

ABOVE: The looks on the faces of the bride and groom as the best man makes the toast have far more impact than just a photograph of the best man.

CANON EOS 1N, 85MM f1.2 LENS, f3.5 AT 1/60, KODAK T-MAX 400

ABOVE LEFT: CANON EOS 1N, 85MM f1.2 LENS, f2.0 AT 1/60, KODAK T-MAX 400

LEFT: Use the videographer's light to capture the image without a flash.

CANON EOS 1N, 85MM f1.2 LENS, f1.2 AT 1/60, KODAK T-MAX 400

THERE'S NO REASON TO BE INTRUSIVE WHILE SHOOTING THE FIRST DANCE. USING **LONGER LENSES** WILL HELP YOU STAY OUTSIDE THE ACTION TO BE THE ULTIMATE OBSERVER. PREFOCUSING HERE IS A NECESSITY. PRACTICE FOCUSING AT HOME IN A DARK ROOM UNTIL THE TECHNIQUE BECOMES SECOND NATURE.

FOR LIGHTING, BAMBI USES TWO **VISATEC MONOLIGHTS** AND RECOMMENDS THE HEAVIEST LIGHT STANDS YOU CAN FIND. SET UP THE STANDS AT EITHER SIDE OF THE DANCE FLOOR, HIDING THEM BEHIND EITHER THE BAND OR THE DJ STAND, AND PUSH THEM TO THEIR MAXIMUM HEIGHT (APPROXIMATELY THIRTEEN FEET). KEEP THE POWER OUTPUTS LOW, AT NO MORE THAN F4, AND AIM THE LIGHTS DOWN TOWARD THE DANCE FLOOR. (YOU DON'T NEED TO LIGHT UP A WHITE CEILING.) THE LIGHTS WILL PROVIDE AN IDEAL RIM LIGHT, SEPARATING THE SUBJECTS' HAIR FROM THE BACKGROUND.

BAMBI THEN RECOMMENDS USING A SHUTTER SPEED OF 1/15 AT F5.6 FOR A SHALLOW DEPTH OF FIELD. HER LENSES OF CHOICE ON THE DANCE FLOOR ARE HASSELBLAD'S 50MM CF AND 100MM CF.

THE FIRST DANCE

The only way a photographer can miss the emotion in the room during the first dance is to simply not be there! Images of the bride and groom dancing are of course important, but don't forget to look around the room and capture the expressions of friends and family as they watch.

You have at least five full minutes during the first dance, giving you the opportunity to use different films and lenses to push your creative talents to the max. Plus, that videographer who's more than likely been in your way half the night now becomes a new assistant. Take advantage of the light from the video setup and switch to black-and-white film. Your images will suddenly have a completely different, more romantic look. Everything doesn't have to be tack sharp.

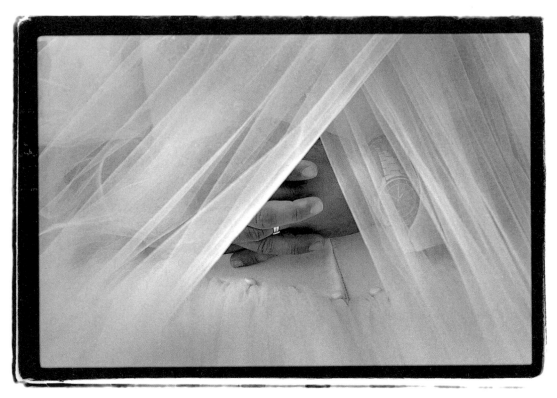

As we've said before, a bride will have the tiniest waist of her life. Notice the groom's hands around that waist during the first dance.

CANON EOS 1N, 85MM f1.2 LENS, f3.5 AT 1/60, KODAK T-MAX 400

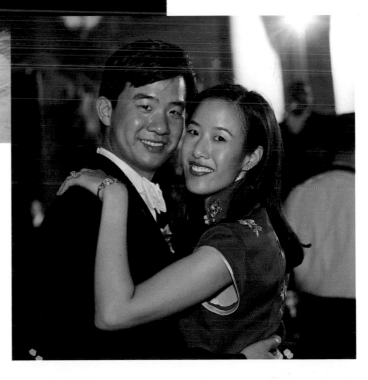

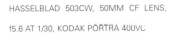

HASSELBLAD 503CW, 50MM CF LENS,

f5.6 AT 1/30, KODAK PORTRA 400VC

Notice how the room lights help
to highlight the hair, especially
with dark-haired subjects.

HASSELBLAD 503CW, 100MM CF LENS,

f5.6 AT 1/30, KODAK PORTRA 400VC

Not all of the action is on the dance floor. Keep one eye on the grandmothers at all times!

HASSELBLAD 503CW, 50MM CF LENS, f5.6 AT 1/30, KODAK TRI-X 320

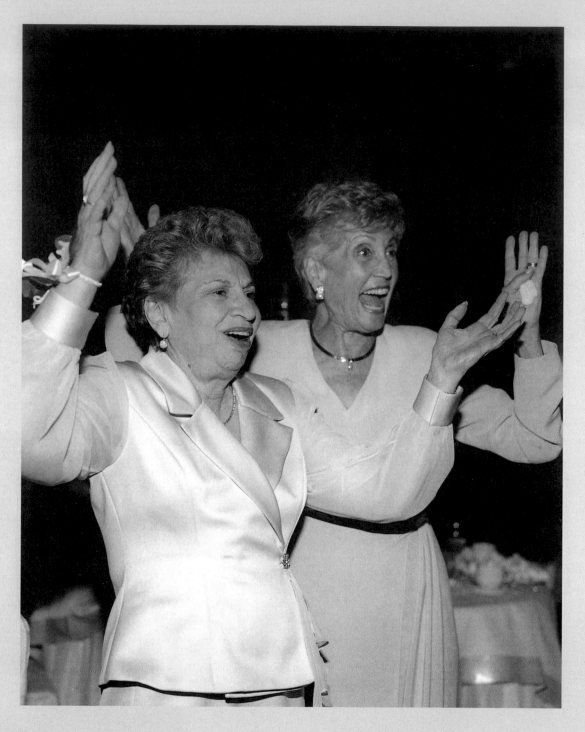

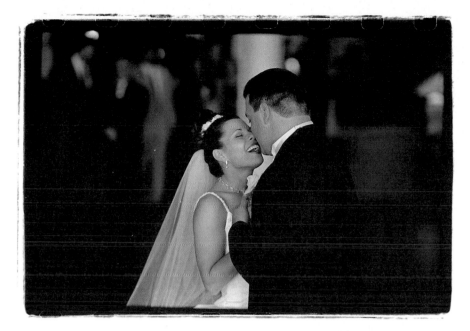

CANON EOS 1N, 85MM f1.2 LENS, f2.0 AT

1/60, KODAK T-MAX 400

The first dance is the perfect time to experiment. Try recording a feeling of movement by dragging the shutter and using only ambient light. For this image, the flash, which was set on "B" mode, fired, but Bambi kept the shutter open for approximately two seconds. The camera was on a tripod and a cable release was used.

HASSELBLAD 503CW, 50MM CF LENS, f4.0 ON "B" MODE, KODAK TRI-X 320

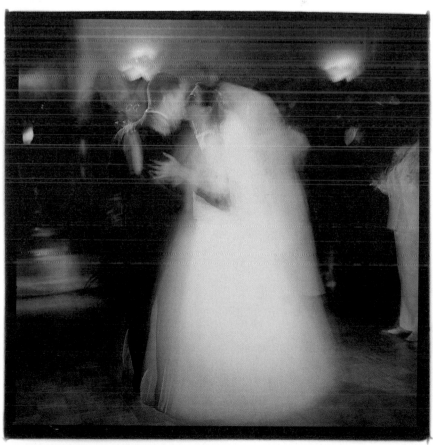

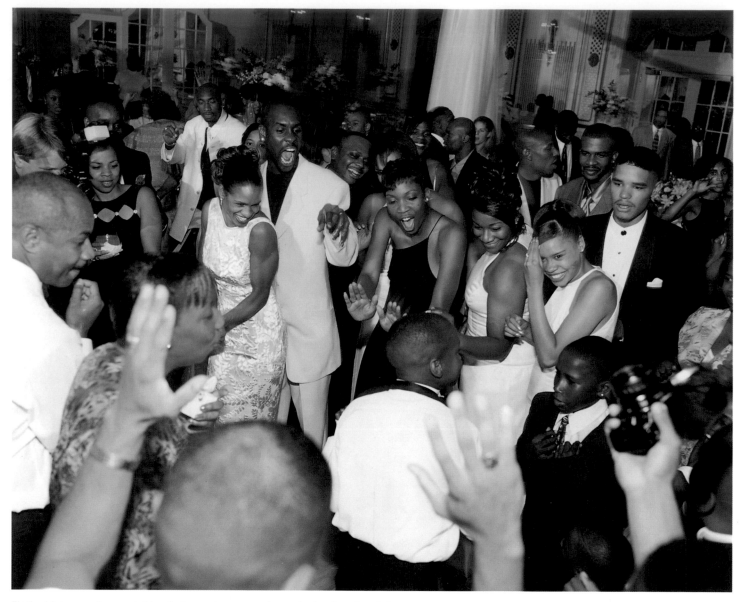

Find a higher vantage point to photograph groups of people dancing the night away.

HASSELBLAD 503CW, 50MM CF LENS, f5.6 AT 1/15, KODAK PMC400, MAIN LIGHT PROVIDED BY ON-CAMERA QUANTUM Q-FLASH SET AT f5.6, ACCENT LIGHT PROVIDED BY VISATEC 1600 MONOLIGHT SET AT f4.0

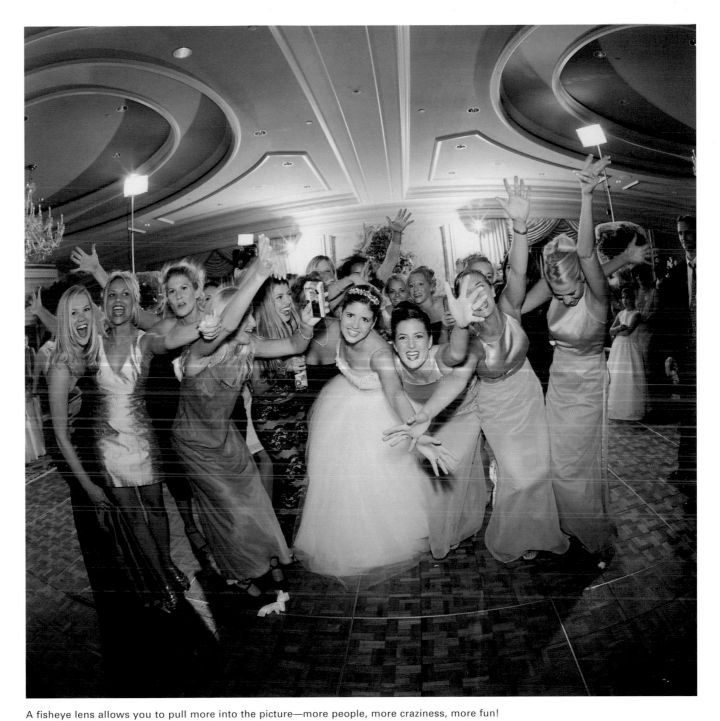

A fisheye lens allows you to pull more into the picture—more people, more craziness, more fun!

HASSELBLAD 503CW, 30MM CF FISHEYE LENS, f5.6 AT 1/30, KODAK PORTRA 400VC, MAIN LIGHT PROVIDED BY ON-CAMERA QUANTUM Q-FLASH SET AT f5.6, ACCENT LIGHT

PROVIDED BY TWO VISATEC 1600 MONOLIGHTS SET AT f4.0

IT'S IMPORTANT TO USE A **SECOND LIGHT SOURCE** WHEN SHOOTING THE CUTTING OF THE CAKE. YOUR MAIN LIGHT SHOULD BE SET AT F8.0 AND PLACED ON A MONOPOD WITH YOUR ASSISTANT ON ONE SIDE OF THE CAKE. THE SECONDARY, ON-CAMERA FLASH SHOULD BE AT F5.6 WITH THE CAMERA APERTURE AT F8.0. THE GOAL IS TO HAVE THE MAIN LIGHT SKIMMING ACROSS THE FRONT OF THE CAKE TO CREATE SHADOW DETAIL WHILE THE ON-CAMERA FLASH FILLS OUT THE IMAGE.

CUTTING THE CAKE

Fewer and fewer couples are doing the bouquet and garter toss, leaving the last vestige of the traditional wedding reception the cutting of the cake. Cake shots can be fun and add a nice element to the album, but only if they're done right. For some photographers, this can be the toughest part of the event as it usually involves a lot of shooting white on white: the cake, the gown, and so on. You should have already caught a good cake shot earlier, so this is the time to concentrate on the subjects and their interaction. Use that 100mm Hasselblad lens to come in a little tighter on the subjects' faces.

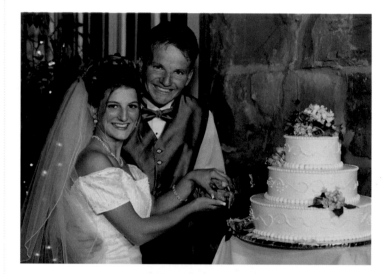

Be prepared to capture the detail in the cake—and stay out of the way!

HASSELBLAD 503CW, 50MM CF LENS, f5.6 AT 1/30, KODAK PORTRA 400VC

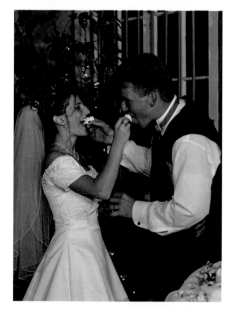
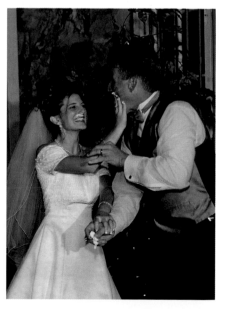

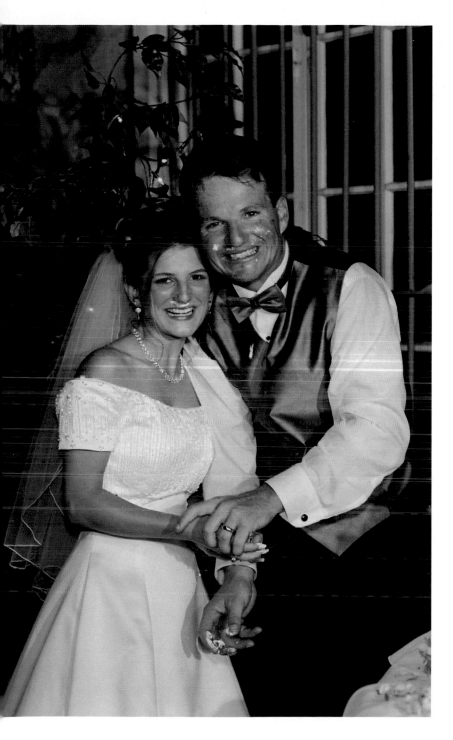

Two lights were used to create this image. The on-camera flash was set at f5.6, while the off-camera flash was set at f5.6 1/2. The off-camera flash served as the main light source, set directly to the right of the cake, while the on-camera flash was the fill.

HASSELBLAD 503CW, 100MM CF LENS, f5.6 AT 1/15, KODAK PORTRA 400VC

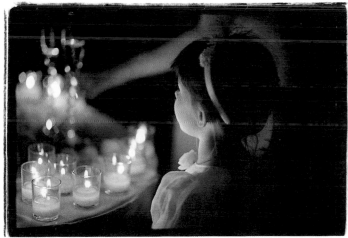

Pay attention to everything around you during the cake-cutting, including little girls and boys waiting for the first piece.

CANON EOS 1N, 85MM f1.2 LENS, f1.2 AT 1/60, KODAK T-MAX 400

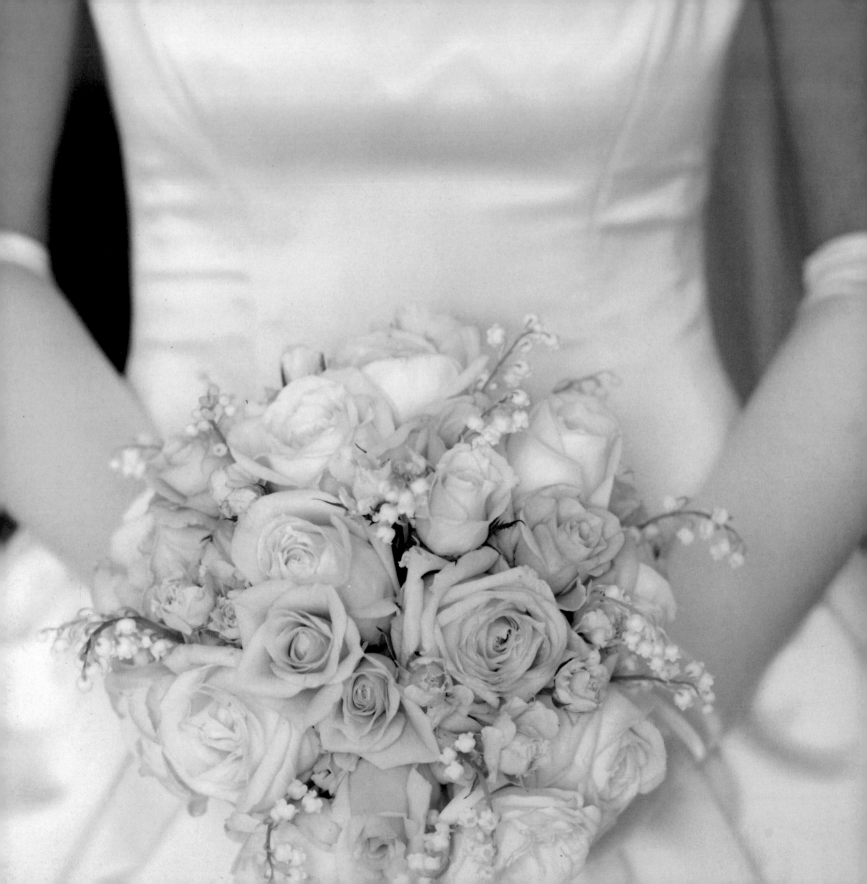

When it comes right down to it, wedding photographers are selling a product: the wedding album. If the album is just a collection of photographs, then you haven't done your job.

However, if you've truly captured the emotion of the day, the album will be a testimony to the celebration of a new family, as well as to your skills as a storyteller. Obviously, the rates you charge for your services should reflect the demographics of your target market. But it's also important to remember the responsibility placed on you for documenting the event. The way you handle this phase of the process will have a lot to do with your business's growth. In short, your clients have to feel they've gotten their money's worth, whatever the cost.

Don't be afraid to give your services the value they deserve.

THE WEDDING ALBUM

The goal of every great wedding photographer is to tell the complete story of the wedding, and your job as a storyteller is just beginning with the first snap of the shutter. The real work is being able to take the emotions you've captured on film and put them into the pages of the wedding album. A good album will demonstrate your effectiveness as a storyteller, and will be your best advertising vehicle.

Invite the bride and groom to come in as soon as possible after the wedding to review all the images. The atmosphere should be relaxed and the couple encouraged to bring other family members. Because Bambi's clients generally come within a week of returning from their honeymoon, the air is charged with excitement. In fact, Bambi has succeeded in making the first look at the "proofs" part of the series of wedding events. What started with the first engagement party ends in her living room, with champagne and a family excited to look at images of the wedding. An added benefit is that this is the first time Bambi, as the photographer, is able to see her clients' reactions to the images.

As anyone in sales knows, you have to strike while the iron is hot. Get your clients interested in your product while they're most excited about the images. How much more effective would you be if you met with more of your clients right after their weddings instead of weeks or even months later?

In the mid-1990s, Bambi made the decision to go proofless. The decision was purely a financial one: Proofs were a huge part of her annual expenses. Instead, she started using a software program called Montage, by Art Leather Manufacturing. Montage is designed to help you bring all of your images together electronically, to lay out the story of the wedding in the most efficient and effective way possible. It allows you not only to bypass proofs and reduce your overall expenses, but also to deliver a better final product to your clients.

To use Montage, send your film to the lab and ask them to put the images on a CD, or scan the negatives into electronic form yourself. Once Montage is installed on your computer, simply load the images into the program and follow the step-by-step instructions.

Montage allows clients to view images on a monitor in a slide show format put to music. Start by asking the bride and groom to simply select all the photographs they like. While it's the bride and groom who ultimately choose the images for the album, you are their guide and play a significant role in their decision-making. Any image with impact qualifies and should be included in their selection. If you want, you can even connect your system to a VCR and record the slide show on a video for the couple to take with them after the viewing. The bride will never take an entire set of proofs with her, but the video goes right into her purse!

You never know who will see this videotape, making it an easy way to increase exposure to potential customers.

Montage then allows the clients to see each page on screen as it's designed to their personal taste. Just like a good book, start the album from the beginning. It's not rocket science. For many photographers, designing the album is actually the most fun and rewarding part of the process. It starts with those terrific images you took of the bride and groom preparing on the day of the wedding. Here's where your film selection and talent as a photojournalist really pays off.

Build the album following the sequence of the wedding day. The story should simply unfold in the order events took place. If you concentrate on telling the story, rather than worrying about how many images or pages are going to be in the album, you'll be far more effective.

It's also important to think about the formats of images in the album. Too often photographers use a cookie-cutter process, offering all the images in just one size. But the highest impact albums are by photographers who allow the images to dictate the formats. A mixture of differently sized images and layouts will have far greater appeal than an album made up completely of 8 × 10s. You might, for example, have a double-page panorama followed by eight smaller images spread over two pages. (Note also that you shouldn't mix black-and-white and color photographs on the same two page spread.)

Images and layouts like the one shown below will appeal to the more traditional members of the family.

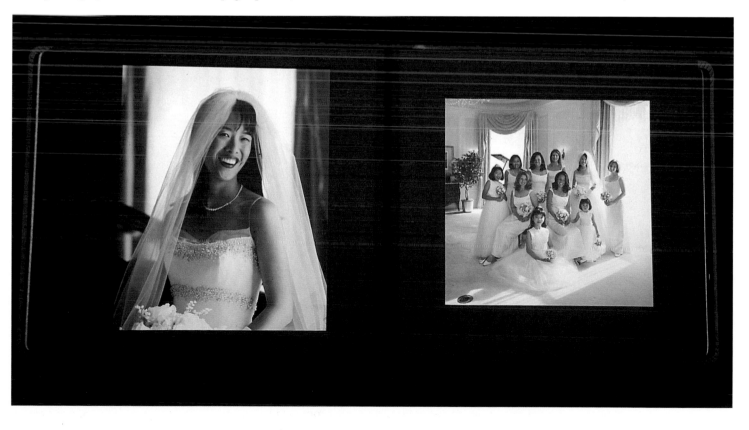

It's important not to overdo the special effects in an album. Keep it simple. Don't get carried away with too many double-page spreads, hand-colored images, or cross-processed and infrared shots. Like cooking with exotic spices, you just want a sprinkle of these images to assist in telling the story, not to dominate the event.

You don't need to fill every page for the album to have impact. Smaller, more powerful images will have a fine-art look when placed by themselves on larger album pages.

Once the pages have been designed, print out layouts for the clients to view. Then send the order to your lab to process the prints in the desired formats. Order an album—we recommend those from Art Leather—and when you've received both the album and prints, assemble the album to match your Montage-generated layouts. For more information about Montage, call Art Leather at 888-252-5286 (in New York City, call 718-699-6300).

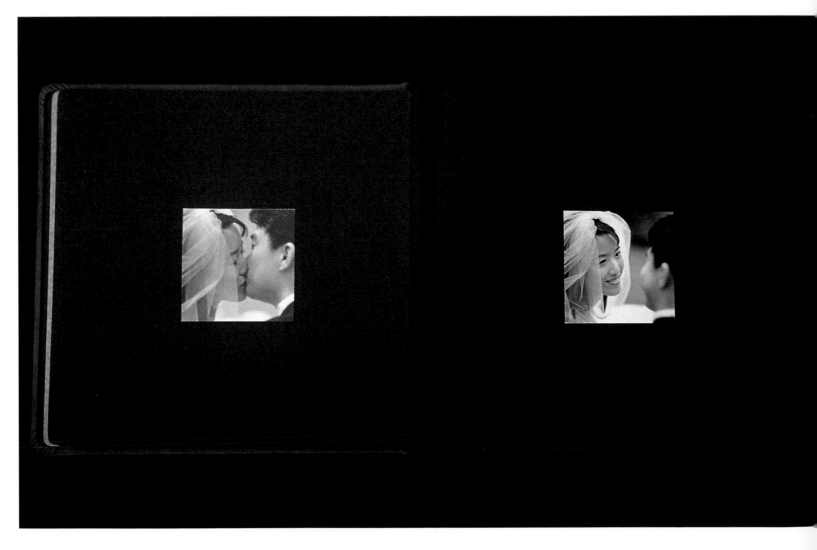

PRICING

When figuring out your pricing structure, don't be afraid to give yourself the value you and the wedding album deserve. We have to recognize that our clients aren't paying for just the material the images are printed on, but what's on that photographic paper. You've spent thousands of dollars on equipment, classes, promotional materials, and so on to become the best possible photographer you can be. Your creative skills are incredibly valuable. No one else was entrusted with the responsibility of documenting the event, and it's important to be compensated for your talents. We're not here as hobbyists with cameras, we're professional photographers and this is how we earn our living.

Opinions from icons in the industry regarding how much wedding photography should cost range from ten to twenty percent of the family's total wedding expense. However, how much you're paid is entirely dependent on how you market yourself and sell your product. It's the perceived value of your services that's going to set the price point.

Here's the only objective information we're going to give you on pricing: Bambi starts figuring her pricing by thinking about how much her time is worth. What's it going to take for her to give up a weekend with her family? Next, she looks at all her expenses: the cost of buying, processing, and printing the film; the album; production costs; travel, if appropriate; and her assistant's pay if she's not shooting alone. Her bottom line is the total of all those expenses plus an appropriate markup.

One of Bambi's greatest tools for showing clients the value of her services is an antique photo album—essentially, another family's heirloom. Using antique photographs will help you demonstrate the lasting value of having your wedding photographed properly. After all, the couple in those images would hardly have cared how much they were paying their photographer if they knew the images would someday be shown to generations so far in the future. Years after the wedding, the album's primary purpose will be to answer the question, "Grandma, what were you and Grandpa like when you got married?" and even later, "What were my ancestors like?"

PACKAGE PRICING VERSUS "À LA CARTE"

The advantage to package pricing over charging "à la carte" is that it's the simplest for both you and the client to understand. You want to make your pricing as easy and flexible as possible. If a client chooses the least expensive type of coverage but then wants to scale up and get additional photographs, the change should be easy to understand and simple to do.

Help your clients see that they're buying a complete product. The bride paid one price for her gown, not several invoices showing material, labor, and delivery. You might, for example, design your packages to include a set number of pages in the wedding album. Don't be

concerned about specifying the number or size of images per page. This will allow you to help the bride and groom design the album. By the time you and your clients reach the agreed-upon number of pages, the clients will have a better understanding of the process. Additional charges can then be billed on a per page basis as you work together to create their customized album.

Your billing system should also be clear. One option is to have each client pay the total bill in three payments: the first due when you're hired, the second due ninety days before the wedding, and the third due the week before the wedding day. The band, the reception hall, the florist, and the caterer are all paid in advance. The wedding album is the most enduring product to come out of the event, yet too often photographers, because of the way they market themselves, are the last to be paid.

Because Bambi sells her images as a package and takes payment in advance, relations with her clients remain relaxed and she doesn't have to be a high-pressure salesperson. This also makes the selection process more efficient: How many times have you seen paper proofs come back with markings all over the back of the prints? First the clients wanted a print in their album, but then, as they added up the cost, the image was dropped. Getting paid in advance also allows you to better plan budgets and manage cash flow. What's the average time it takes for clients to decide which images they want in their album? All this time, the à la carte photographer is waiting with his or her income stream at a standstill.

THE CONTRACT

Without question, you should never photograph a wedding without a contract. And while every state has slightly different consumer protection laws, there are several universal points every contract should cover:

1. *The services to be performed.* This includes the hours of coverage and the number of images or pages in the album. You should also define the level of interest in black-and-white versus color, and the type of album to be provided.
2. *A time limit on ordering both the album and reprints.* You don't want to push too hard, but Bambi recently had an indignant bride on her hands who couldn't understand why Bambi's prices had changed since she first received her proofs nine years ago! It's also important to state how long you'll keep the film.
3. *Your payment plan.* We recommend having everything paid for before the wedding day. Photographers who insist on chasing a bill afterwards are at a distinct disadvantage.
4. *A model release.* Whether or not you think you might want to use images from this wedding in your own promotional materials, it's still a good idea to have a model release as part of your contract (see opposite). If you're photographing a celebrity or someone who simply doesn't want you to ever use any of the images, the model release is the easiest thing in the contract to discard.

5. *A cancellation clause.* Always include a cancellation clause with penalties proportionate to the amount of advance notice given prior to the wedding date. Remember, the closer you are to the actual date, the more difficult it will be for you to find another client and, obviously, the greater the responsibility on your client to carry the burden of your loss of income.
6. *A liability clause.* You should always have a liability clause to protect yourself in the event of unforeseen problems or accidents outside your control.
7. *The clients' signatures.* Make sure both the bride and groom sign the contract.

The purpose of the contract isn't to create a legal nightmare for your clients, but to help educate both them and their photographer. It's simply a way to make sure everyone understands each other's expectations.

MODEL RELEASE

Date _____

For valuable consideration, I hereby irrevocably consent to and authorize the use and reproduction by you, or anyone authorized by you, of any and all photographs that you have this day taken of me, negative or positive, proofs of which are hereto attached, for any purpose whatsoever, without further compensation to me. All negatives and positives, together with the prints, shall constitute your property, solely and completely.

Model _____

Address _____ Phone _____

City _____ State _____ Zip _____

Signature _____

Signature of Parent or Guardian _____

A sample model release. Please note that wording may vary depending on the legalities regarding usage of specific images.

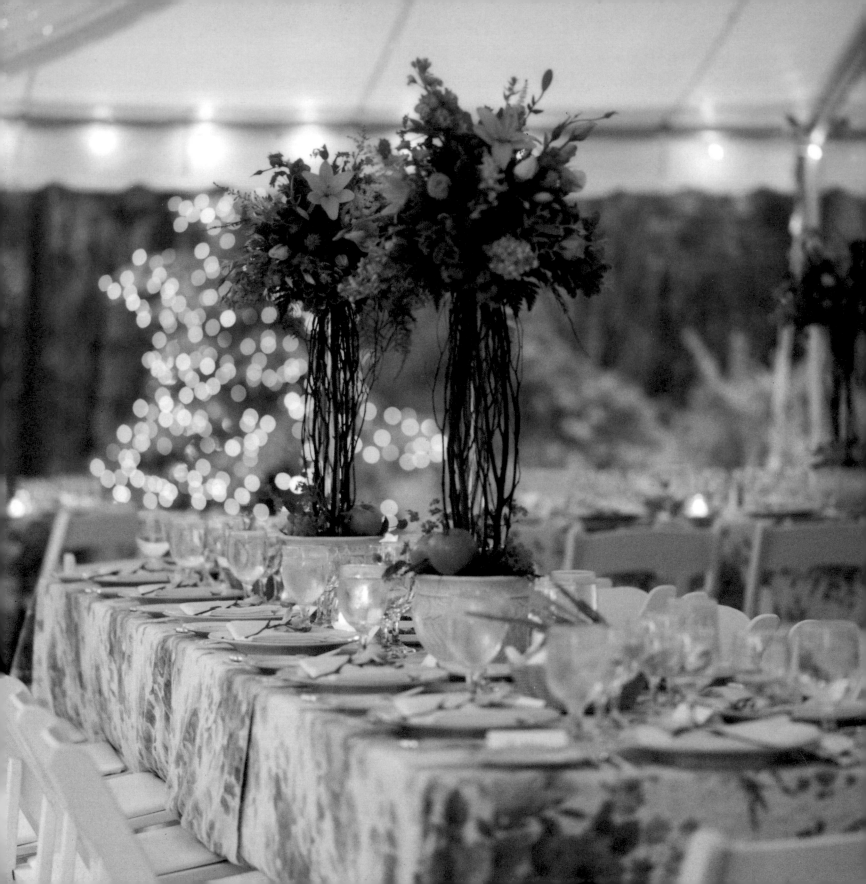

MARKETING YOUR SERVICES

The business of wedding photography is more dependent on word of mouth than perhaps any other specialty within professional photography. Just one satisfied (or unsatisfied) client has the ability to influence hundreds of other potential customers. But no matter how talented you are, you first need to get noticed, and then to nurture and build your client base. And the way to do that

You never get a second chance to make a first impression.

is by making smart marketing decisions, by maximizing your exposure to target clients, and by designing sales materials with impact.

SALES MATERIALS WITH IMPACT

You never get a second chance to make a first impression. Like the images you researched in consumer magazines, your sales materials must have impact and powerful emotional appeal.

DESIGNING A BROCHURE

Let's start by making your images work for you in a strong brochure designed to attract your target clientele.

The first step is to simply lock yourself up for the day without interruption. Hold all calls and concentrate on designing your brochure. Review a dozen magazines read by your target clientele—*Vogue, Elegant Bride, Martha Stewart Living,* and *Elle,* just to name a few. Look for typefaces with impact and the types of photographs used. Even ideas on ways to word your materials are right there on the pages in front of you. We're not suggesting you plagiarize material, but use it to help you get ideas on communicating more effectively. Let's face it, most of us don't have a degree in marketing, but the tools we need to fake it are right there at our fingertips.

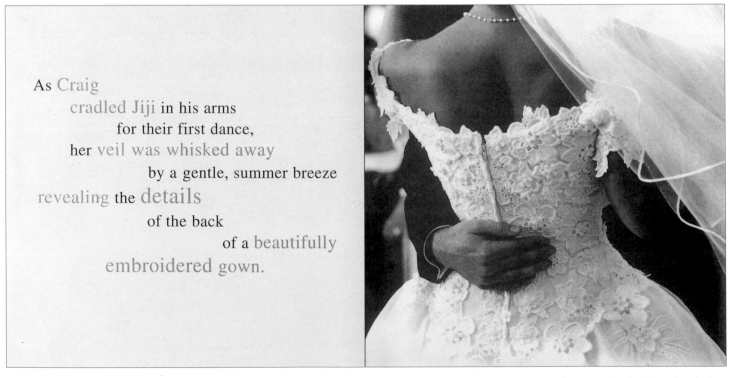

As Craig
 cradled Jiji in his arms
 for their first dance,
her veil was whisked away
 by a gentle, summer breeze
revealing the details
 of the back
 of a beautifully
 embroidered gown.

A sample spread from the inside of Bambi's brochure. Bambi designed her brochure as a 5- × 5-inch black-and-white storybook with a simple font and type design, and romantic images. The result is a high-impact brochure that was voted the best marketing material of 1997 by Professional Photographers of America.

Step two is to lay out the images you're thinking about using. Choose the image you feel has the most impact for the cover. Black-and-white images, sloppy borders, and so on all add to the impact. Be careful not to select too many images; less is better. Ever walk by the windows of a store like Tiffany's? Its windows are small and you'll rarely see more than two or three outstanding pieces displayed in each. The goal is simply to get you to come into the store. They don't need to show everything in their inventory.

You might also consider an unusual size for your brochure, to help it stand out. Remember, your potential client is going to come home from a bridal fair with all kinds of brochures and materials. You want your brochure to jump out and scream, "Pick me!" It should also have a design and print quality that appeals to your target audience. Choose your papers carefully. If your clients are more upscale, they're going to notice a difference between generic photocopy paper and Crane's stationery.

Design the brochure to scale so it's the size you want it to be. If you're going to be using it as a mailer, check on postage with the post office. You can mail any size brochure, but different sizes have different costs.

Next, you'll need to think about what you want the brochure to say. Keep in mind that the brochure has only one purpose: to get the client in your door. Because your work is visual and you want the brochure to have impact, be careful not to be "copy heavy." Look back at the magazine ads. How much copy is there in relation to the size of the photograph of the product? At the same time, try not to make your copy trite or too trendy. You'll want to use the piece for an extended period of time, so you don't want it to date quickly. You might want to add a testimonial or two from past clients. Just make sure you get their permission first.

Don't print your prices directly in the brochure. Instead, include a pricelist in a small envelope as an enclosure. This allows you to change your pricing as necessary. Also, include a clearly stated caveat for how long the prices are in effect.

Finally, make sure you work with a reputable printing company. A good printer can work with you to customize any type of brochure. Should you want a customized-looking piece without the challenge of creating everything from scratch, many printers have large selections of predesigned pieces. A good printer will also have a staff of art directors whose sole purpose is to help clients design their marketing materials. One printer that makes it easy to design and print your own promotional materials is Marathon Press; check out their Web site at www.marathonpress.com, or call them at 800-228-0629.

Once you've completed your brochure, take a serious look at your business card. You're missing an incredible opportunity if your support material lacks continuity. Your business card is simply an extension of your brochure and also has one purpose: to remind clients who you are.

CANON EOS 1N, 85MM f1.2 LENS, f5.6 AT 1/125, KODAK T-MAX 400

Building a Portfolio

Your portfolio, especially in the wedding industry, is your calling card. When you finally have an opportunity to show your work to a prospective client, it's not just the individual photographs that have to grab them, but the overall presentation. Just as your brochure is meant to "hook" a potential client and get him or her in the door, your portfolio is intended to land the assignment.

Your portfolio should demonstrate a variety of different images, all of them with impact: It's quality, not quantity. When selecting your images, think back to the consumer trends you should have researched. Remember, the biggest trend in photography today is a push toward photojournalism. It's there in virtually every ad, whether in magazines or on television. Black-and-white photography is back with a vengeance, in perhaps the highest demand since the 1940s.

Also keep in mind that "pretty sells." Just like an ad agency building an ad campaign, you need beautiful and interesting locations with the people to match. And not only do you need attractive people but, more importantly, you need to capture their personalities on film. No manufacturer ever sold a product using unattractive people or bad photography. Remember, we're talking about building a collection of images that you'll be using in brochures, direct mail pieces, and at bridal fairs, not just to show to clients. And what if every client isn't as beautiful as the people in your portfolio? Guess what: It doesn't matter. Your job is to attract the bride and her mother using the same techniques a Madison Avenue ad agency uses every day of the week.

If you're just starting out and don't yet have images from actual weddings, there's nothing wrong with using models. You don't need high-priced modeling talent, just a couple of friends who interact well together and a location with impact to help you demonstrate your photographic abilities to potential clients.

Let's take a look at some high-impact images Bambi might use in building her portfolio.

In our modern world we can give our clients virtually anything they ask for. Did you ever think about designing a CD of your images? Don't underestimate the power of having your own CD. In a country where more computers were sold in recent years than televisions, CDs have never been more powerful as selling tools.

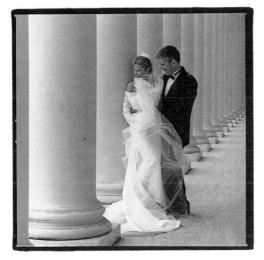

A single 3 × 3 image placed off-center on an 8 × 10 mat will have more impact than one 5 × 5 or 8 × 8 print and will have a stronger, fine art look.

HASSELBLAD 503CW, 150MM CF LENS, f5.6 AT 1/125, KODAK T-MAX 400

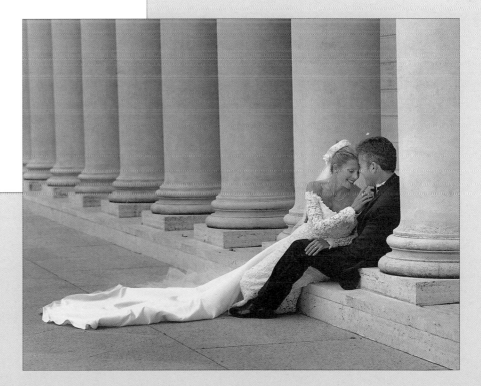

HASSELBLAD 503CW, 100MM CF LENS, f5.6 AT 1/125, KODAK T-MAX 400

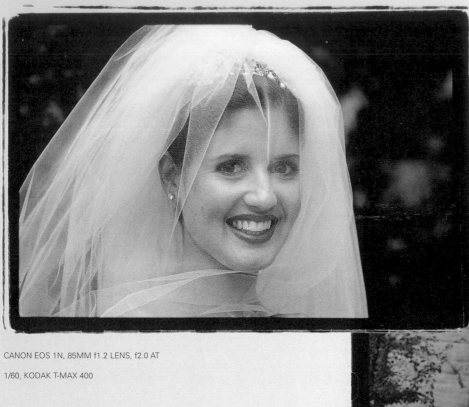

CANON EOS 1N, 85MM f1.2 LENS, f2.0 AT

1/60, KODAK T-MAX 400

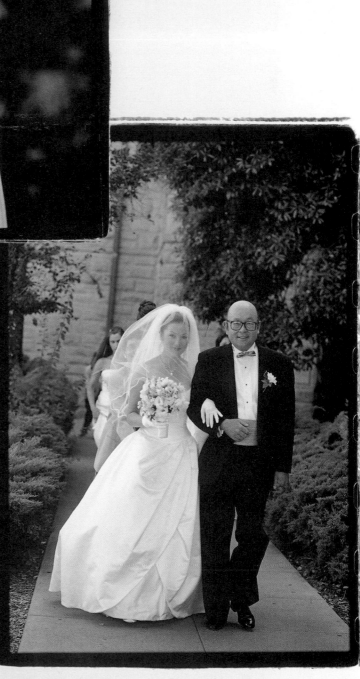

CANON EOS 1N, 85MM f1.2 LENS, f5.6 AT

1/60, KODAK T-MAX 400

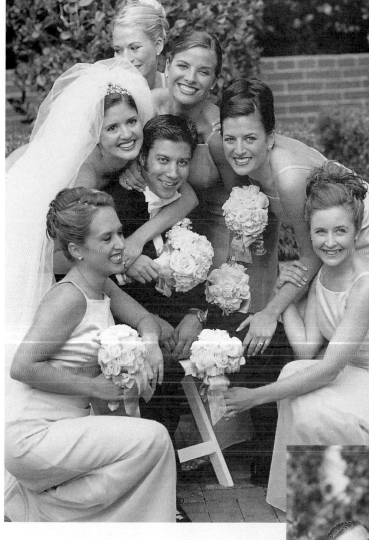

CANON EOS 1N, 85MM f1.2 LENS, f5.6 AT

1/125, KODAK T-MAX 400

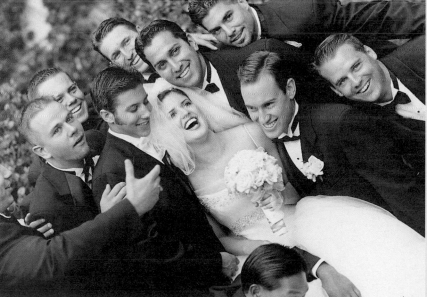

CANON EOS 1N, 85MM f1.2 LENS, f5.6 AT

1/125, KODAK T-MAX 400

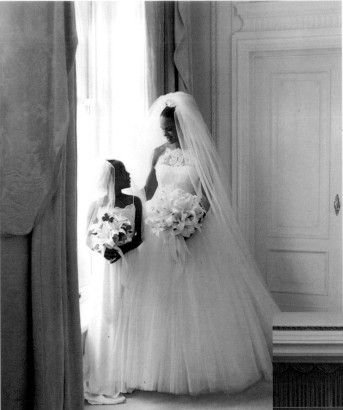

Basic color photography should still be the foundation of your portfolio. It helps to support the expectations of the more traditional members of the family.

LEFT: HASSELBLAD 503CW, 50MM CF LENS, f5.6 AT 1/30, KODAK PORTRA 400NC

BELOW: HASSELBLAD 503CW, 50MM CF LENS, f8.0 AT 1/15, KODAK PORTRA 400VC, MAIN LIGHT PROVIDED BY QUANTUM Q-FLASH SET AT f8.0 AND MOUNTED ON A MONOPOD, FILL LIGHT PROVIDED BY ON-CAMERA QUANTUM Q-FLASH SET AT f5.6

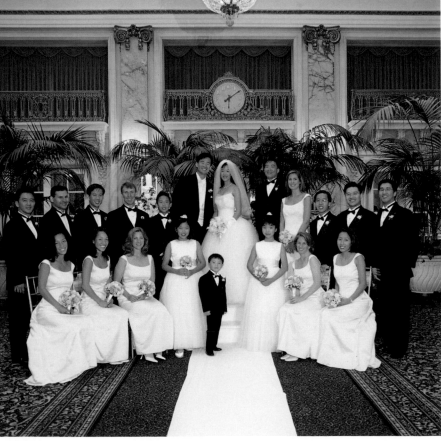

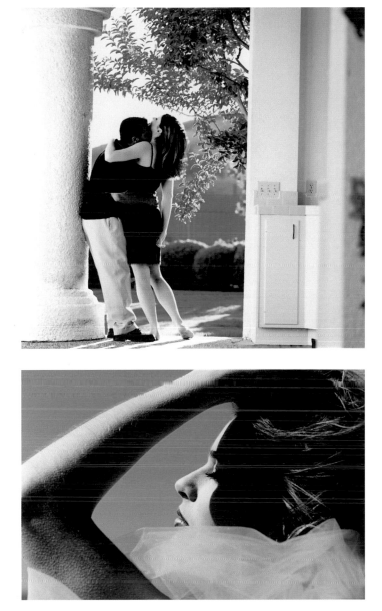

Consider one or two hand-colored images to add a touch of artistry to your portfolio. It's a five-minute project virtually guaranteed to create more interest in your work. See page 43 for more details on hand-coloring.

CANON EOS 1N, 85MM f1.2 LENS, f5.6 AT 1/125, KODAK T-MAX 400

ABOVE, TOP: While color photographs appeal to Mom, the bride, especially if she's younger, is going to be moved by a more electric look. See page 84 for details on cross-processing.

HASSELBLAD 503CW, 100MM CF LENS, f5.6 AT 1/125, KODAK EKTACHROME 100VS

ABOVE, BOTTOM: Include at least one tightly cropped face shot to add impact and drama, and to demonstrate your creative skills.

CANON EOS 1N, 85MM f1.2 LENS, f5.6 AT 1/250, KODAK EKTACHROME 100VS

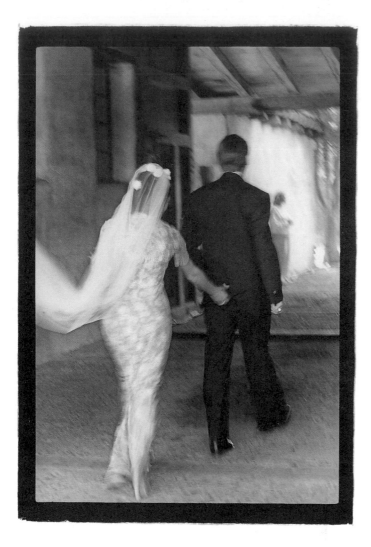

Print full frame "sloppy borders"
in interesting sizes.
CANON EOS 1N, 35–105MM ZOOM LENS,
f5.6 AT 1/30, KODAK T-MAX 400

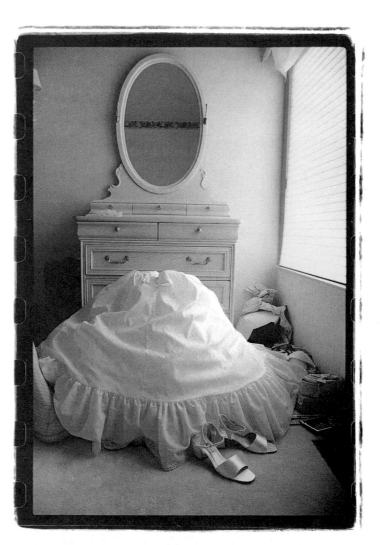

Don't overlook the more exotic
films like Kodak T-Max P3200,
which is also a nice film for
hand-coloring.
CANON EOS 1N, 85MM f1.2 LENS, f2.0 AT
1/60, KODAK T-MAX P3200 RATED AT 1600

Infrared film is wonderful for creating drama and intensity in your images. It turns an ordinary location into something extraordinary. (See page 40 for more details on using infrared film.) For this image, a 29B red filter was used and the film was rated at 100 speed.

LEICA R4, 50MM f2.0 LENS, f2.0 AT 1/60, KODAK HIGH-SPEED INFRARED RATED AT 100

INCREASING SALES AND IMPACT: THE IMAGE BOX

The image box is the most revolutionary product to hit the professional photographic market in years. It has the potential to increase your sales and re-orders for additional prints throughout the year. If used correctly, it can become one of the strongest selling tools in the industry.

WHAT IT IS

Physically, the Image Box is simply a beautiful box designed to look like an album. It's available through Art Leather Manufacturing in three sizes—small, medium, and large—and in almost as many colors as Art Leather albums, with the same choice of leather versus leatherette. You can also emboss the cover in the same way you'd customize an album, with an embossed square or rectangle where you can add a photograph. Inside the Image Box are a variety of mattes that can be cut to virtually any size.

At some point during the wedding—perhaps during the rehearsal dinner, reception, or a brunch the next day—Bambi will pass around several blank mattes to people she's identified as those most special to the bride and groom, asking each to write something to the couple directly on a matte. She'll have the parents of the bride sign one and the groom's parents sign another. She'll circulate another matte among the bridesmaids. Grandparents, siblings, and anyone else close to the bride and groom will get his or her own matte. The completed product is the box filled with images, each set in a matte with a personal, handwritten message.

The Image Box provides a way to capture a grandmother's sentiments in her own handwriting on the day of the wedding.

The Image Box, available through Art Leather, shown here in a couple of sizes and colors.

Imagine the impact of presenting this to your clients; what product could have more lasting sentimental appeal? The Image Box is designed to complement the wedding album, not compete with it. It's meant to hold only a limited number of outstanding images, each with its own story to tell. The box is designed to sit on a coffee table or bookshelf, or the images can be displayed one at a time on an inexpensive tabletop easel (sold in virtually any store that sells picture frames).

SELLING WITH THE IMAGE BOX

Whether you're building the Image Box into your pricing up front, or using it purely as a sales and marketing tool, there's no other product with such potential to build your business. Unlike so many products designed by manufacturers who think they know our industry, the Image Box was designed by Bambi herself. It has helped separate her from competitors and expand her presentation beyond just the traditional album.

One of the distinct advantages of the Image Box is that it can be used in so many ways. You might, for example, build it into your package free of charge but ship it to the bride and groom with empty mattes. On the back of the mattes you could attach certificates appropriate for various milestones in their lives: a free sitting for a first anniversary portrait, a photograph of the first child, and so on. For those of you who also do children's photography, the Image Box is the perfect way to get Mom into the studio every year for portraits of the kids. Once again, you're using the Image Box as a marketing vehicle: selling it on its own with a series of discounts or free sittings to get the client back in your studio. No pun intended, but by now you should be getting the picture!

The Image Box is an outstanding presentation kit for showing work to prospective clients. It's also an ideal product to use in building relationships with hotels, restaurants, florists, wedding coordinators, and others. Imagine giving a hotel an Image Box filled with images you took of a wedding held there. The hotel has a new tool for selling itself to future clients, and the wedding coordinator in the hotel sales office will now refer all of his or her clients to you. For more information about the Image Box, contact Art Leather (see page 118 for contact information).

The biggest frustration for photographers at bridal fairs is potential clients who "hog" the albums. You've taken the time to create an attractive display; you don't want people walking away because they perceived you were just too busy or didn't have enough material to show them. This is where the Image Box comes in. It enables you to have eighteen matted prints to hand out two or three at a time to clients while they're waiting to examine one of your albums. Plus, it gives you a conversation point to introduce yourself and your work.

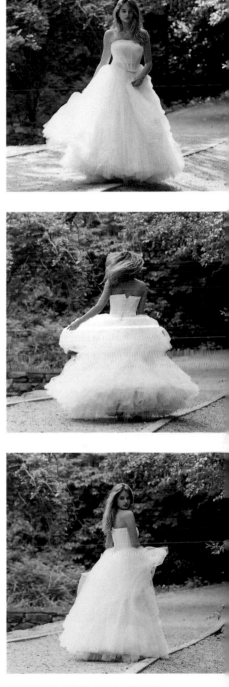

HASSELBLAD 503CW, 100MM CF LENS, f5.6 AT 1/250, KODAK PORTRA 800 RATED AT 620

WORKING BRIDAL FAIRS

Done the right way, a bridal fair can be one of your strongest vehicles for finding new clients. Done the wrong way, you're guaranteed to be wasting your time and, if you're not careful, to even be turning people away.

Most bridal fairs take place between January and March, but you don't need to work every single event. Identify the fairs that typically attract your target clientele. Bridal fairs are usually advertised in local magazines and newspapers; you need to find out about them early in order to be an exhibitor. A bridal consultant or catering manager in your area should be able to direct you to a coordinator for the bridal fairs nearest you.

The key to success at a bridal fair is a booth in the inside of a center aisle, on the corner. You want traffic flow from at least three directions. You also need a booth that stands out from the competition and gives people a reason to stop.

Just as with your brochure, you want to design your booth to have impact. Remember Tiffany's? Your booth needs just two or three strong display points, each with only two high-impact photographs. And while awards are nice, leave the ribbons at home.

How do you show the prints? It's Tiffany's all over again. Spend the money, which is minimal, on spotters to light the prints. Look at the way jewelry is displayed, each piece lit so as to draw the eye toward it.

To decorate the booth without incurring high expenses, try networking with other professionals at the fair. Work with a local florist, for example, to cross-promote each other's services. You don't need a lot of flowers, just enough to accent the booth and give the florist added exposure. You can also network for some of your furnishings. Bambi's booth is decorated entirely through her networking with florists and a local interior decorator.

A bridal fair can be one of your strongest vehicles for finding new clients.

A bridal fair isn't a failure if you don't book any weddings. Think about the other exhibitors you can impact: hotel managers, caterers, videographers, florists, and even other photographers. You want to develop relationships with everyone who can help your business grow. (Also see "Networking," page 141.)

COMMUNICATING WITH POTENTIAL CLIENTS

If you've ever attended one of Bambi's seminars, you know that she's perhaps the only photographer in the industry who spends at least a half hour before her program meeting and introducing herself to the people attending. She simply loves to know who she's talking to, the kinds of businesses they have, and their interest in photography.

BUILDING YOUR BOOTH

It's not difficult to construct your own simple, 8- × 10-foot booth for use in bridal fairs. Here's what you'll need:

- two lightweight hollow interior doors, each 4- × 8-feet and without the hole for the doorknob
- crown molding for the top of the doors. The crown molding should be approximately 4 inches deep.
- three spotter halogen track lights for each display
- 4- × 8-foot sheets of plywood to build the base for each door
- tongue-and-groove plywood in 3- × 3-foot sections that fit together for the floor
- marbelized peel-and-stick tile to cover the floor

Assemble the bases, then paint the bases, doors, and moldings with a neutral color. Attach the molding and track lighting to each door. To make the floor, fit the tongue-and-groove plywood sections together, then cover each section with marbelized peel-and-stick tile. (Alternatively, just buy a piece of carpet!) Once the floor is complete, secure the bases onto the floor and slide each door into a base. Hang your displays and furnish tastefully.

Bambi's bridal fair booth. The booth is only 8 × 10 feet, but notice how open it is, giving the impression of a much larger display. The design actually invites people in to view the images. You want potential clients to feel welcome in your booth, not like they're on the outside looking in. The layout and three viewing stations make the booth not only incredibly efficient but also different from the typical wedding presentation.

So what should you do when potential clients enter your booth? If we were to actually script Bambi meeting new clients at a bridal fair, here are some of the questions she would ask:

- Hi, I'm Bambi Cantrell, and your name is?
- When is your wedding?
- What are you looking for in a photographer?
- What are your concerns in working with a photographer?
- How do you feel about black-and-white photography?
- How much involvement do you want from your photographer on the wedding day?

You may have noticed that Bambi asks several viewpoint questions, designed to show interest in the client and give her a better perspective of what he or she is looking for in a photographer. When asked about pricing, she openly offers her pricelist. There's no need to be secretive about your pricing or to be a high-pressure salesperson.

There's also no need to promote your services with a twenty-four-hour sign-up-today-or-die sales pitch. Your goal is to be soft-sell, to not push too hard. You want to demonstrate your ability to relieve the pressure of the wedding day, not add to it. It's reverse psychology at its best and it works.

CANON EOS 1N, 85MM f1.2 LENS, f5.6 AT
1/60, KODAK T-MAX 400

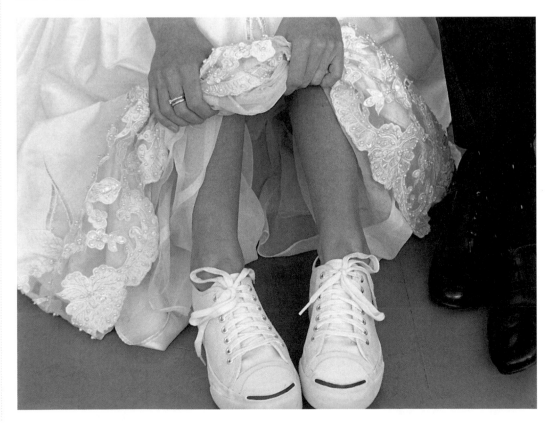

INCREASING YOUR EXPOSURE

You know how to handle exposure for your camera, but what about increasing exposure for your business? Here are some quick and relatively simple ideas for getting added exposure.

IN YOUR COMMUNITY

With a little ingenuity, you can turn almost any retail or office outlet in your community into a "gallery" for your work. The trick is to pick those places most likely to attract your target market.

Doctors' offices are perfect places to try and show your work. Most are decorated exactly the same way: Every wall has a poster, probably from Kmart, maybe Ansel Adams or travel posters. How about suggesting a collection of photographs to your family physician? It's free for the doctor and all it takes from you is a little time spent decorating the waiting room every couple of months. In the corner or in a small cardholder, leave a few of your brochures or business cards. Think of the impact. And if you're matching your images to the profile of the doctor's patients, it's a win-win situation.

Cafés and restaurants are other examples. Nobody loves coffee more than Americans, and the café environment is ideal for offers to decorate the walls. In fact, we've been in more than one café already decorated with photography—it's typically scenic and fine art, but that doesn't exclude you from working to develop relationships and look for opportunities. The same is true for restaurants in general. Again, they're places in which your target clients are likely to congregate and have time on their hands. Remember, you're in a visual profession; here's an ideal opportunity for you to become master of the soft sell.

The location of your studio or office is another important factor to consider. If you're opening a portrait studio or wedding business, for example, you'll want a community with lots of young faces. You're not going to create much excitement in a community with a high percentage of retirees! Consider the businesses around you and try to establish yourself close to those same doctors whose walls you just decorated. They're accessible and will have a never-ending stream of potential clients.

ON THE WEB

The days of promoting your business through an ad in the yellow pages or expensive direct mail are long gone. Your first line of advertising will be word-of-mouth from past clients and other wedding vendors, particularly when you're doing an outstanding job. The second is cyberspace, the planning and research tool for today's brides and grooms.

Cyberspace has completely changed our lives. In the United States alone, there are more computers sold each year than televisions. And as a photographer, the Internet is an ideal medium for promoting your skills and showing an easily updated portfolio.

CANON EOS 1N, 85MM f1.2 LENS, f5.6 AT

1/125, KODAK T-MAX 400

Every photographer should, without question, have a Web site. It can be as complex as you choose to make it. If you can afford it, have the site professionally designed. At a minimum, the site should include a description of your photography philosophy, a little information about who you are, and some representational images. Don't junk up your site with a lot of copy; keep it clean and simple with a few high-impact shots.

And while creating your Web site is a first step in business building, garnering hits from brides-to-be is surely next. It only makes sense to look to popular wedding sites like the Knot (www.theknot.com)—the Web leader with more than one million visitors each month—to feed traffic to your site. The Knot's Wedding Photographer's Network (WPN) is a popular, searchable database of member photographers organized by locale, specialty, and minimum fee charged. Brides are particularly drawn to WPN because it goes so far beyond other sites, most of which only provide listings based on location. The best part is that WPN, in essence, does the work of actually qualifying your leads: Only those wanting service in your area, style, and price range are directed to your listing and Web site. Kodak's affiliation means that frequent buyer "ProRewards points" can defray the entire cost of the listing. For more information, see WPN's informational site for photographers at www.wedphotonet.com.

WORKING OUT OF YOUR HOME

If you're building a business in your home, pay attention to the following details to help you build a professional image:

- Decorate the room you're going to be using as your studio or viewing room with your very best images. Light each print on the wall with individual lights or ceiling spotters.
- Decorate with neutral colors.
- Use furniture that's comfortable and warm and reflects an image of timeless class. In other words, stay away from being too contemporary and trendy.
- If you've got a family, spend the money to insulate the room. You want an atmosphere that's quiet and without interruptions. Most importantly, keep the kids out when you're with a client.
- Switch off the ringer on your phone when you're with a client and let the answering machine pick up calls. Your clients have to feel that you're completely dedicated to them.
- Put out a vase of fresh flowers every week.
- If you have pets, keep them out of the room while you're meeting with clients.

You're not at a disadvantage just because you're working out of your home. In fact, a lot of photographers feel—especially in a family-oriented business like wedding photography—that working out of the home helps reflect your personality, in turn helping to build a closer relationship with the client.

NETWORKING

"Network" is one of those words that didn't exist as a verb until just a few years ago. Now networking is an important key to your business's growth, not to mention its survival. Unfortunately, too many photographers think networking means handing out hundreds of business cards. For our purposes we'll define networking as the process of building relationships and turning every contact you make into an ambassador for your business.

CONSUMER BUNDLING

Donald Libey, an outstanding business consultant and author, defined *consumer bundling* as the process of noncompeting companies working together and sharing costs, such as for advertising, to reach a common target. So why can't photographers do the same thing?

What would happen if a wedding photographer teamed up with a caterer, a tuxedo shop, and a florist for a direct mail campaign? How about a photographer and bridal shop working together and sharing the cost of advertising? What about a wedding photographer and children's photographer teaming up with a local children's clothing store for advertising or direct mail?

At one workshop, we heard about a photographer who'd approached a local landscape designer. The landscaper went on to build him a very expensive, beautiful fishpond, which the photographer went on to use for all his family portraits. All the landscaper asked for in exchange was that the photographer recommend him to people he photographed. Out-of-pocket costs for the photographer were zero! Go back to page 137 and look at the photograph of Bambi's bridal fair booth. The flowers and furniture are usually supplied at no charge. She's made it a point to develop and nurture relationships with vendors whom she can help and who can also help her.

Got the picture? Your goal is to build a team of people and/or companies who will help you increase business, decrease expenses, and reach your common target: future brides.

TRADE SHOWS, SEMINARS, AND CONVENTIONS

There are no better places to network than at trade shows, seminars, and conventions. It's one thing to collect business cards, but another altogether to establish relationships. You need to attend every possible convention you can, especially in the first five years of your business.

Your first goal is to get to know anyone making a product who supports your business. Ever notice Denis Reggie at a trade show? You'll see him talking with friends at Hasselblad, Kodak, Canon, Bogen, and Art Leather, just to name a few. These aren't just companies who sponsor some of his programs, but friends he's established over the past twenty years as a professional photographer.

You also need to build relationships with other photographers. That's right, we're suggesting you build relationships with your competitors. In the wedding business especially, there are only so many dates you're going to have open in any given year. You can't photograph every wed-

Providing images like this to the florist after a wedding will help you build your "team" of ambassadors.

HASSELBLAD 503CW, 100MM CF LENS, f4.0 AT 1/250, KODAK PORTRA 400VC

ding that comes your way. So why not refer a client to a competitor whose work you admire and respect? That same competitor now becomes an ally and will refer work back to you in the same way.

Just as your body needs nourishment, so does your mind. Attending every possible industry seminar will help you develop new ideas for creating the very finest images. The key to success for many of the best photographers in our industry is their never-ending quest for continued education.

COMMUNITY INVOLVEMENT

This topic really deserves its own chapter but we're putting it under "Networking" because it has the same purpose: to give you added exposure and help build your business.

Just a few years back, marketing guru Jay Conrad Levinson was speaking at a Professional Photographers of America seminar, talking about the top one hundred things "guerrilla" marketers need to do. At the top of the list was a statement about consumers wanting to purchase products from companies they perceived as giving something back to society. It's important that your studio support the people who'll eventually become your client base. As wedding photographers typically shoot only on the weekends, you have a degree of flexibility in your schedule during the week. Take advantage of that flexibility to build relationships in local organizations and key community charities. Get involved!

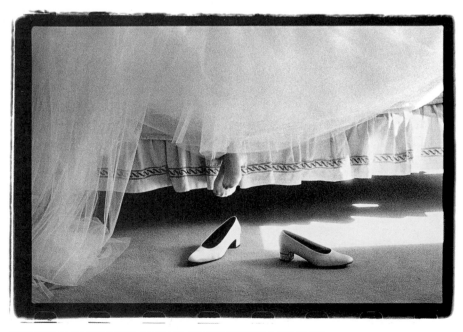

CANON EOS 1N, 85MM f1.2 LENS, f2.0 AT 1/60, KODAK T-MAX P3200 RATED AT 1600

FINAL THOUGHTS

Professional photographers have documented all aspects of the human experience, from the violation of human rights to the tear in a father's eye as he walks his daughter down the aisle. We have the ability to stop time, to capture moments through the lens of our camera.

As wedding photographers, our clients trust us to see a wedding through not only their eyes, but also their hearts. As a result, success takes more than just great camera gear. You have to understand the aspects of the wedding day, your clients' expectations, and the tension of the event. You have to enjoy listening to and interacting with people, and be alert to every emotion. You must be able to work independently and outside the studio environment. And of course, you have to master the principles of photography. Wedding photographers are given free reign for maximum creativity with every client. You owe it to both your clients and yourself to be the very best you can be, to capture those poignant images an average photographer would miss.

Whatever else it is, wedding photography is an opportunity to simply have fun. Remember that word? It's a word too often lost in today's business environment. Good wedding photographers not only enjoy positive feedback from their clients, but often become extensions of these new families. If you're not having fun in wedding photography, take a step back and look at your business and how you photograph. What drew you to wedding photography in the first place? When it's done properly, we believe that the act of capturing the celebration of a new family offers greater personal satisfaction than any other segment of photography.

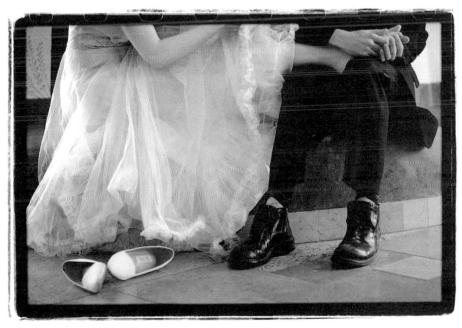

CANON EOS 1N, 85MM f1.2 LENS, f5.6 AT 1/60, KODAK T-MAX 400

INDEX